S

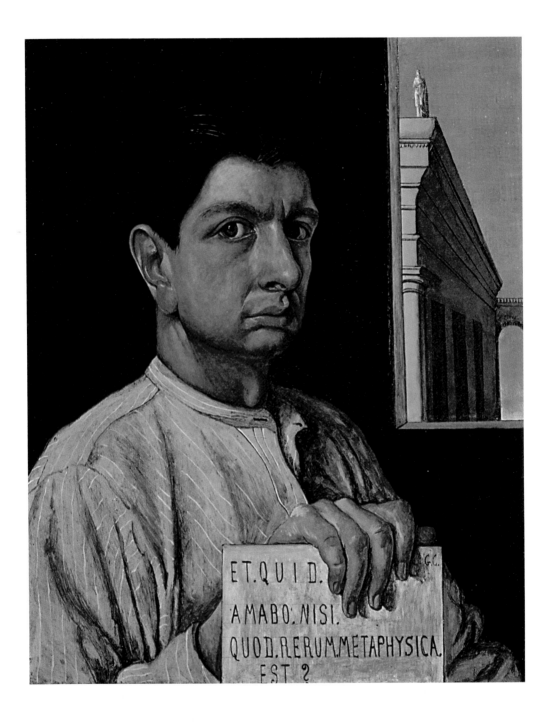

Wieland Schmied

# Giorgio de Chirico
## The Endless Journey

Prestel

Munich · Berlin · London · New York

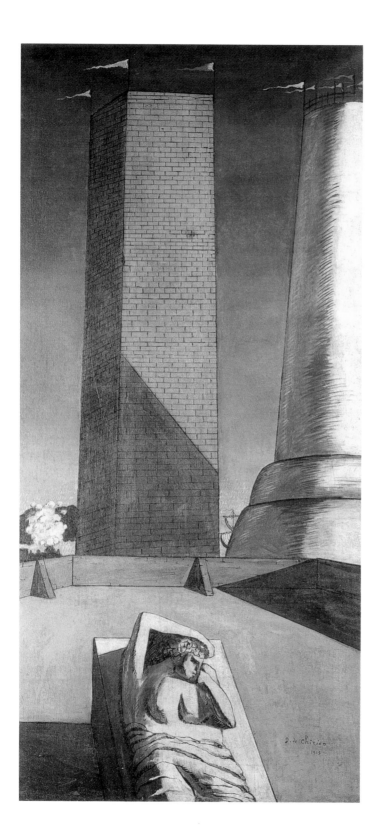

# Contents

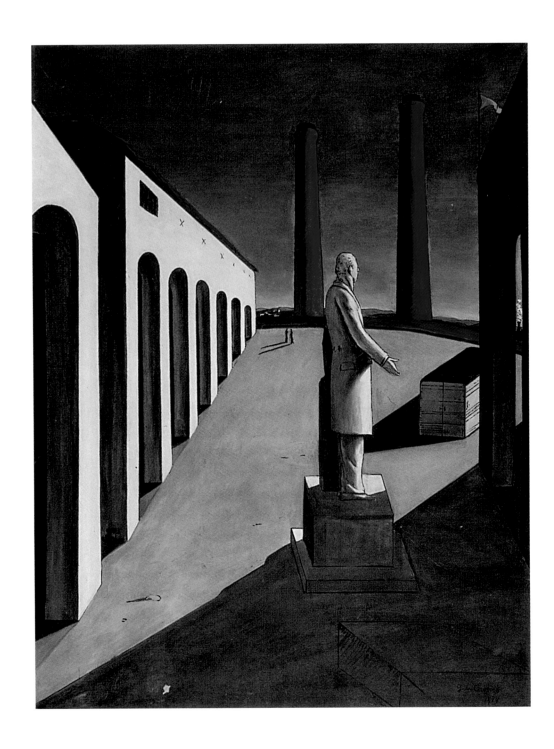

*The Enigma of a Day,* 1914
Oil on canvas, 185.5 x 139.7 cm
The Museum of Modern Art, New York
James Thrall Soby Bequest

# Prologue: Exposé of a Drama

Giorgio de Chirico turned to a work by a predecessor at an early stage in his attempts to introduce the human figure into his increasingly personal pictorial world: Arnold Böcklin's painting of Ulysses, homesick and preparing to depart after seven years from Ogygia, Calypso's island. This image made an unforgettable impression on de Chirico. It marked the first step on an 'Endless Journey.'

At first, de Chirico introduced the Ulysses figure into his own painting with very few changes. He shifted it into the background, reducing it in size until it vanished entirely, or occurred as a mere shadow. Subsequently he moved the figure back into the centre, where it now appeared stiffened, petrified into a statue, a monument.

A crucial point in this journey was an experience de Chirico had in autumn 1909, on Piazza Santa Croce in Florence, where a statue of Dante appeared to him with the force of a revelation. He began to subject the statue to a series of transformations, lending it various roles, culminating in that of a *manichino*, a faceless tailor's dummy or artist's lay figure. The idea went back to the painter's meeting with the poet Guillaume Apollinaire, and to an exchange of ideas with his, de Chirico's, brother Alberto Savinio. All of this took place on the eve of World War I, in the atmosphere of the journal edited by Apollinaire, *Les Soirées de Paris*.

During the war years, which he spent in Ferrara, de Chirico then set out to redefine the human figure, depicting it as an accumulation of wooden frameworks or geometrical implements, as in *The Great Metaphysician*. This work would trigger a profound reaction on the part of Max Ernst. In his paintings of 1921 to 1923, which have been aptly described as 'painted collages,' Ernst took it upon himself to breathe new – if wierdly dreamlike – life into de Chirico's immobilized figures, thus preparing the ground for Surrealism.

De Chirico made a strange about-turn at the same time. He abandoned modernism and turned his attention to the human image as conveyed to posterity by the sculpture of ancient Greece and Rome.

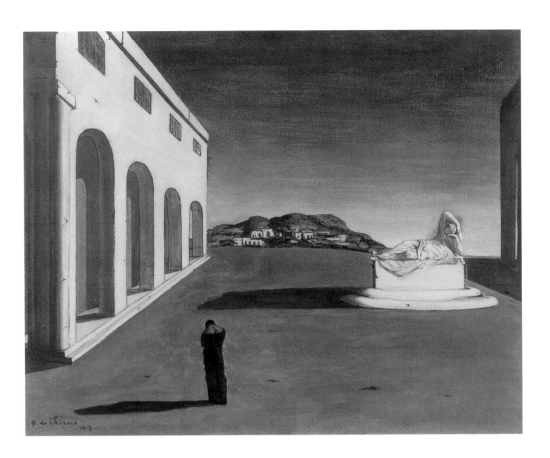

*The Melancholy of a Beautiful Day*, 1913
Oil on canvas, 89 x 104.5 cm
Musées Royaux des Beaux-Arts de
Belgique, Brussels

On closer scrutiny, the metamorphoses undergone by the human image from Böcklin to de Chirico are like the successive acts of a drama. After becoming petrified into a statue, monument or column, the figure was transformed into a *manichino,* then reanimated in the shape of the dream creatures and hybrid beings that populate the proto-Surrealist painting of Max Ernst. In what follows we shall trace the key phases of this drama. It truly was, as one of de Chirico's titles has it, an 'Endless Journey.'

*The Troubadour*, 1917
Oil on canvas, 91 x 57 cm
Private collection

# Act I
## Ulysses and Calypso:
## Inspiration

Arnold Böcklin – Giorgio de Chirico – Max Ernst: three figures in a story of inspiration. Actually, of inspiration twice over, both instances of which took place in Munich. And strangely, in both cases this illuminating spark, this moment of inspiration was triggered not by original works of art, but by black and white reproductions.

In the winter of 1906–07, Giorgio de Chirico, a young art student from Athens, enrolled at the Munich Academy, the Akademie der Bildenden Künste. In his spasre time Giorgio used to accompany his brother Andrea, later to be known as Alberto Savinio, to the latter's private counterpoint and harmony lessons with the composer Max Reger. Giorgio spoke fluent German, and Andrea almost none, so Giorgio was asked to translate. But his services not being continually required, Giorgio settled himself down in a corner of the room, where a large album of photogravures lay on a table: *Arnold Böcklin*, edited by Heinrich Alfred Schmid.

Böcklin – Giorgio had heard the name back in Athens. He began to glance through the album – and soon could not put it down. That 'spark of poetry' about which Max Ernst so often spoke, had leapt the gap. Böcklin became the young de Chirico's idol. Subsequent visits to the Schack Gallery and the Neue Pinakothek, where he saw the originals, deepened his fascination with the Basel master, if adding no further aspects to it – something that might have provided Julius Meier-Graefe with fresh arguments in his campaign against Böcklin.

But of all the reproductions, the picture that most impressed the young de Chirico was Böcklin's *Ulysses and Calypso*, 1883 (see pp. 12/13). The figure of Ulysses, totally absorbed in himself, was one with which any young artist could readily identify. It became the starting-point of de Chirico's attempt to introduce human figures into the pictorial world that he was soon to call 'metaphysical,' borrowing from the philosophy of Nietzsche. We shall see where this experiment led him.

Change of scene: late summer 1919. Max Ernst has come to Munich with his wife and his friend Alfred F. Gruenwald (who would later adopt the pen name Johannes Theodor Baargeld), to hike in the Bavarian Alps, and to visit Paul Klee. Klee drew

their attention to a bookshop and gallery run by Hans Goltz. It was there that Max Ernst discovered de Chirico – in reproductions printed in the short-lived Roman journal *Valori Plastici*, which was distributed in Germany by Goltz. Decades later, Ernst would still stress how powerful an impression these reproductions had made

*The Enigma of the Oracle*, 1909
Oil on canvas, 42 x 61 cm
Private collection

on him. They had struck him with the force of a revelation – the same word de Chirico applied to his discovery of Böcklin.

There is another remarkable parallel here. Both de Chirico and Ernst later recalled having a *déjà-vu* experience in face of this inspiring imagery. It was as if they had already seen this unknown realm that suddenly opened up before them, although they 'couldn't remember the place or time,' as de Chirico said with respect to Böcklin. And as Ernst recalled, remembering the old issues of *Valori Plastici*: 'I thought I was seeing something long familiar again, as though something I had always known revealed a whole region of my own dream world, which, by interposing a kind of censorship, one had prevented oneself from seeing and understanding.'

# Arnold Böcklin
## *Ulysses and Calypso,* 1883

A slender figure stands on a jutting rock against a cloudy sky, his back to the viewer, looking out to sea. Diagonally opposite, a female figure is seated in front of a dark cavern. Her head is half turned towards the male figure, and her body is presented to the viewer´s gaze. While the standing male figure grips his dark blue cloak tightly around him, the naked female figure sits in a relaxed attitude, on a red cloth spread over the rock and sand at her feet. Her left hand rests on a cithara, as if she has tired of playing it.

Everything in this picture serves to emphasize contrasts that are intended to visualize an insoluble conflict. The standing male figure on the rock is starkly silhouetted against the whitish-grey sky merging with the sea; the pale skin of the female figure is starkly set off by the blackness of the cave, a protective haven.

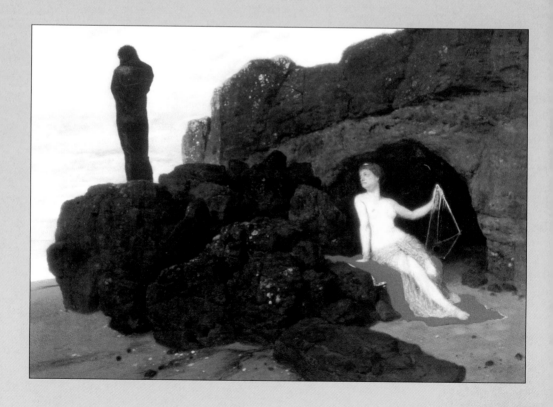

Even more is made of the contrast between blue and red. While the blue of the male figure's cloak encloses and isolates him, the red of the cloth spread out under the female figure is open and inviting. The blue evokes distance, cold, renunciation, mourning; the red proximity, warmth, passion. The contrast is underscored by the rocky zone between the two figures, brown and devoid of vegetation. The landscape element seems to have been suppressed in favour of a focus on the psychological drama.

The shelter of the cave is as little able to entice the man as the nymph's passion or the music of her lyre. He has enjoyed both to the full, and has grown weary of such pleasures. Ulysses has spent seven years on the island of Ogygia – realm of the immortal nymph Calypso – on whose shores he was cast up, as related in the Fifth Canto of Homer's *Odyssey*. Now other shores beckon, those of his homeland, those of his own nature. He hangs his head in profound self-absorption. As he gazes down at the restless sea, he gazes into his own psyche. In the incessantly pounding surf, Ulysses recognizes himself.

Arnold Böcklin
*Ulysses and Calypso*, 1883
Oil on wood, 104 x 150 cm
Kunstmuseum Basel

What was it that de Chirico found so intriguing about Böcklin, and Ernst about de Chirico, that they felt compelled to address it in their own art? For de Chirico it was Böcklin's self-absorbed figures, moods of nature personified, those women beneath the cliffs in *Villa by the Sea* or by the riverbank in his autumnal landscapes – but especially the yearning, introspective figure of Ulysses on Calypso's island. De Chirico spirited these figures from their lonely beaches or sacred groves onto the stage of an entirely artificial world, an abandoned cityscape surrounded by arcades, enclosed by walls, where the figures froze into monuments, petrified into statues. All life around them seemed extinguished.

Max Ernst reacted to this lifelessness as he frequently reacted to the art of others. He objected, contradicted. Ernst redeemed de Chirico's statues from their petrified state, granting them a somnambulistic existence in the midst of a primal wilderness, a nature as if given a new lease of life in the wake of the Deluge.

A few years ago an exhibition arranged by the Kunsthaus Zurich, 'Eine Reise ins Ungewisse (A Journey into Uncertainty): Arnold Böcklin – Giorgio de Chirico – Max Ernst' was shown in Zurich, Munich and Berlin. This presentation was enthusiastically received not only by art historians. Its surprising pictorial confrontations also opened the public's eyes to many, previously covert links and connections. Affinities were revealed where one would hardly have expected them.

One of these astonishing points of contact was between Ernst and Böcklin. It was as though Ernst had overleapt de Chirico's petrified figures and gone straight back to one of Böcklin's favourite motifs, the impenetrable forest and its mystery. Böcklin had taken the myth-laden forests of his northern homeland with him to his beloved Italy. Ernst now proceeded to refashion these forests from the detritus of the Mechanical Age, as if they were part of an ineradicable dream of mankind. How, he seemed to ask, could de Chirico be so fascinated with Böcklin and yet forget his forests, and be satisifed with dead Renaissance arcades and brick walls?

The arc that leads from Böcklin to Ernst links Romanticism with Surrealism. As the 'Böcklin – de Chirico – Max Ernst' exhibition vividly illustrated, a range of Romantic ideas found fresh soil in Surrealism, and set forth new, fascinating, seductive and dangerous blossoms. Böcklin's late art has often been disparaged as excessively literary. Yet it was probably its timeless linking of nature with the art of antiquity, and hence its spiritual and mythological aspect, whose mood touched de Chirico and inspired his *Pittura metafisica* (apart from promptings from Nietzsche's *Thus Spake Zarathustra*).

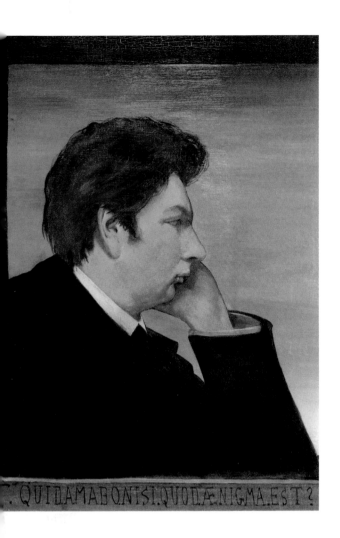

*Self-portrait: "Et quid amabo nisi quod aenigma est"*, 1911
Oil on canvas. 72.5 x 55 cm
Private collection

In his early Paris notes, dating from between 1911 and 1913, de Chirico often mentions how much coming across Böcklin's and Klinger's painting in Munich meant to him – although he soon realized he could not simply continue along the same lines, but had to find a new approach. Then, in the course of his reading – even before Nietzsche had made him see the world through fresh eyes – he experienced a strange coincidence with his earlier Böcklin experience. De Chirico noted: "I was reading. A few lines of Homer captivated me. Ulysses on Calypso's island. I read some of the descriptions, and then the picture stood there in my mind's eye. I felt that I had found something at last ...."

It must have been around that time in Munich that the foundations were laid for *The Enigma of the Oracle*, before de Chirico moved to Milan in summer 1909 (and immersed himself more deeply in his study of Nietzsche). He probably painted the picture before his visits to Florence and Rome in the autumn of that year (about which, more below).

De Chirico might be described, to use Cézanne's words, as the 'primitive of a new art,' not least because of a certain painterly naïveté (if not awkwardness), whose qualities were not to be exhausted in the materiality of colour and form. Böcklin's picture *Ulysses and Calypso* led him, in all innocence, to his own, highly personal style. In *The Enigma of the Oracle* (which should be dated to 1909, not 1910, as hitherto) he shifts the scene to Delphi. The Ulysses figure, wrapped in a toga-like garment and facing away from the viewer, stands at the edge of the paved floor of a rather rudimentary structure – probably intended to represent an abandoned temple – gazing over a hillside village towards the sea in the distance.

With *The Enigma of the Oracle,* de Chirico opened his character-istic game of revealing and concealing, introduced his personal dialectic of suggestions and omissions. Take the two curtains fastened to the plain brick wall, which play a key role here. They give the scene a theatrical quality, changing the temple ruins into an improvised stage. One of the curtains is open, the other closed. That on the left has been drawn back to reveal the horizon and the figure of Ulysses, standing with his back to us. The world would be able to see him as well, if it had eyes for him, if only there were someone below who chanced to look up in his direction.

The other curtain is closed. Over it peers the head of a figure, a statue. Although its face it turned towards us, it is not looking at us. The head is lowered, and not human but made of stone (or plaster). This pose is similar to that of Ulysses, and yet there is a contrast between the two: the statue does not see, but is seen (even though the curtain is closed); the man sees but is not seen, even though the front curtain is open and flapping in the wind.

The colours used in the painting suggest cold and loneliness. The buildings on the hillside appear abandoned; the clouds in the sky are the only things that convey an impression of movement. De Chirico probably had this image in mind when he wrote his essay on 'The Sense of Prehistory,' in Paris in 1913: "In a ruined temple, the broken statue of a god was speaking in a mysterious language. This image always makes me shiver with cold, as if I was caught in a winter wind coming from a distant, unknown land. The time? It is the frosty dawn of a clear day in late spring. The depth of the dome of sky, still as green as the sea, would give anyone a sense of vertigo when he stares into it. He shudders, feels drawn into an abyss. It seems to him as if the heavens lay beneath his feet …
I felt like someone stepping out of the light of day into the twilight of a temple: At first he cannot see the pale statue, but gradually its form congeals and becomes increasingly pure. I was like the artist who was the first to chisel out a god, the first to feel the desire to create a god."

The image of a temple by the sea, where the oracle's often dark prophecy awaits us, obsessed de Chirico as much as the person of Ulysses receiving the prophecy and embarking on a long and uncertain journey. Elsewhere in his early Paris notes, in an entry probably also written in 1913, he described *The Hour of the Enigma*: "When I thought of temples dedicated to the gods of the sea on the arid shores of Greece and Asia Minor, I often conjured up the soothsayers who listened to the voices of the waves …
I painted them, with their heads and bodies huddled in a chlamys, waiting for the oracle's mysterious revelation." Even though the

present painting shows a similar situation, we must note that Ulysses does not appear here as a soothsayer, nor is he awaiting the oracle's pronouncement. He has obviously heard it already, probably from the 'voice behind the curtain,' represented by the concealed statue. Now he is brooding over the prophecy, and gradually realizing its implications. The voice has told him, "If you go to Troy, you will not return until the twentieth year, and then alone and forsaken." So this is the fate that is in store for him! Ulysses is seized by dark premonitions. Does a curse lay on his life? Truly a question conducive to profound melancholy.

*The Enigma of the Oracle* is one of the three paintings that de Chirico submitted to the 'Salon d'Automne' in Paris, the first public showing of his work. It appeared there in October 1912, along with *The Enigma of an Autumn Afternoon* – in which the Ulysses figure fuses with the Dante monument on Piazza Santa Croce in Florence – and with his early self-portrait, also painted in Florence, and subscribed: 'Et quid amabo nisi quod aenigma est' (And what should I love if not riddles?) It was this exhibition that attracted the poet and critic Guillaume Apollinaire's attention to de Chirico, though a year would pass before he wrote about his work. The following winter, poet and painter became personally acquainted, and a strange and wonderful friendship began.

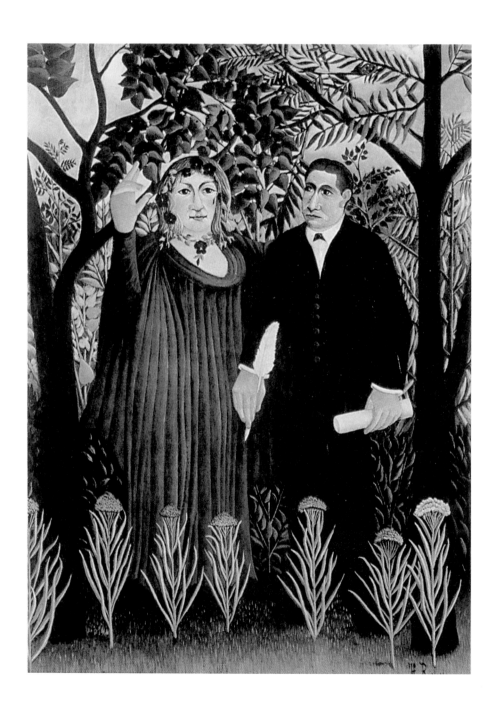

# Act II
# De Chirico meets Apollinaire
# and Paints his Portrait

Henri Rousseau:
*The Muse Inspires the Poet*
(first version), 1908
Oil on canvas, 131 x 97 cm
Pushkin Museum, Moscow

Giorgio de Chirico's *Portrait of Guillaume Apollinaire*, painted in 1914, is a key work for a number of reasons. It is evidence of an encounter between two artists, a painter and a poet, who met in Paris on the eve of World War I, at a historic moment for the avant-garde, and who, as a great deal of evidence suggests, exerted a strange fascination over each other. The portrait is key to an understanding of the complex personality of Guillaume Apollinaire – and at the same time it very clearly reflects the way he saw himself. It is an important milestone in de Chirico's development at the end of his Paris period, and also marked a

*Self-Portrait*, 1913
Oil on canvas, 87.3 x 70 cm
The Metropolitan Museum of Art,
New York, donated by
Fania Marinoff in memory of
Carl van Vechten and Fania Marinoff

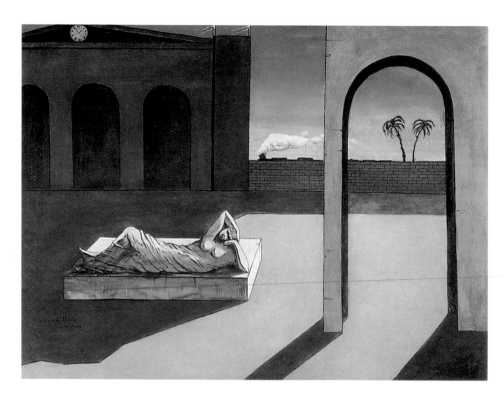

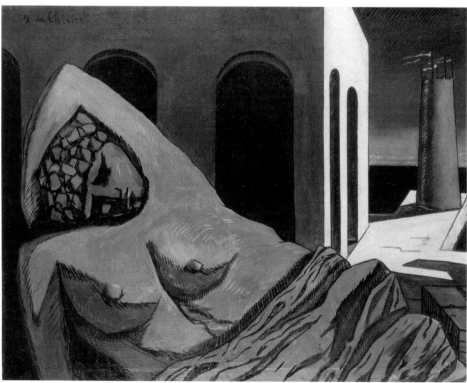

crucial stage on the road to Surrealism, that new movement in art that would be proclaimed by André Breton ten years later, in autumn 1924, in the *First Surrealist Manifesto*. Many of Breton's statements identify both Giorgio de Chirico and Apollinaire as particularly important forerunners of Surrealism. He accords similar respect to Henri Rousseau, who in 1908 painted the other major portrait of Apollinaire, *The Muse Inspires the Poet*, first shown at the Paris 'Salon des Indépendants' in 1909.

It is perfectly understandable that de Chirico and Apollinaire should have been interested in each other. Their personalities and biographies exhibited striking parallels. Both felt themselves to be outsiders – if not aliens – in Paris, no matter how much they tried to acculturate themselves in France and to carve out a respected, if not central, place for themselves on the contemporary Parisian scene. Apollinaire was thirty-four when he sat to de Chirico, eight years his junior, in 1914. The writer had already made considerably more of a name for himself than the painter, who had been living in Paris for just under three years at the time. Only two years had passed since his artistic début in 1912, with three paintings at the 'Salon des Indépendants.'

Reviewing their careers, one finds ever more features in common between Apollinaire and de Chirico. Neither was a native of Paris. Apollinaire was born in Rome, in 1880, as Wilhelm Albert Vladimir Alexander Apollinaris de Kostrowitzky, the illegitimate son of Angelica de Kostrowitzka, who came from Helsinki. To briefly sum up the controversial reports on his origins, on his mother's side they were Polish-Lithuanian-Italian, and on his father's, Bourbon-Grison-Roman. His father was Francesco Flugi d'Aspermont, whose brother was a high papal dignitary in the Vatican. This sparked rumours that Apollinaire's real father was a cardinal.

De Chirico was the son of Italian parents. In his love of mystifications, he always averred that they came from Palermo or Genoa, but as recent research has shown, they actually originated from Smyrna or Istanbul. Giorgio was born in 1888, in Volos, Thessaly, which at that time almost exactly marked the border between Greece and the Ottoman Empire, and where his father, Evaristo de Chirico, was in charge of building a railway line. Both Apollinaire and de Chirico lost their fathers early. M. d'Aspermont left his mistress never to return shortly after the birth of their second son, Guillaume, who was just five at the time. De Chirico's father died when his two sons, Giorgio and Andrea, were seventeen and fourteen respectively. Apollinaire and de Chirico were both brought up by energetic, strong-willed mothers – the one an enterprising adventuress, the other a resolute, highly moral woman.

# Giorgio de Chirico
## *Mystery and Melancholy of a Street*, 1914

Depicted here is an encounter between two figures, a little girl run-
ning with a hoop and the statue of a politician. The presence of the
monument is indicated only by its cast shadow, just as the girl's fig-
ure, back-lit, appears merely as a dark silhouette. She runs in the di-
rection of a hidden source of light, as if drawn by the long shadow
of the statue. As the two figures, living being and man of stone, ap-
proach each other, they become increasingly similar – two shadows
about to meet.

At the same time, this is a confrontation of light with darkness.
The two zones remain strictly separated: On the left, reflected light,
and on the right, the realm of darkness, with a concealed light
source somewhere behind. The white wall with its dark arcade glows
as if lit by floodlights, as does the yellow sandy ground across which
the girl runs. On the right lies the world of shadows, the building and
its arches plunged in gloom. Parked here at an odd angle is an emp-
ty goods or furniture van. Its side and doors are mysteriously bright,
lit by light from nowhere. Is this the afterglow of bygone days, or the
reflection of a reflection? The girl has crossed the train tracks to run
past the lorry – or will curiosity tempt her to explore it?

An image shot through with mystery and melancholy. But its
greatest mystery is contained in the perspective. It is based on two
mutually contradictory vanishing points, one for the illumination and
the other for the dark areas. All the lines of the building that stands
in full light converge to the right, above the horizon and behind the
dark building. Yet the vanishing point of the dark area lies near the
conjunction of the black roof of the van, the dark yellow of its side,
and the lighter yellow of the ground. These two vanishing points will
never converge, just as the girl will never reach the shadow of the
statue. In his 'metaphysical period' de Chirico found unforgettable
images for the tragedy of the inanimate world.

*Mystery and Melancholy of a Street*,
1914
Oil on canvas, 87 x 71.5 cm
Private collection

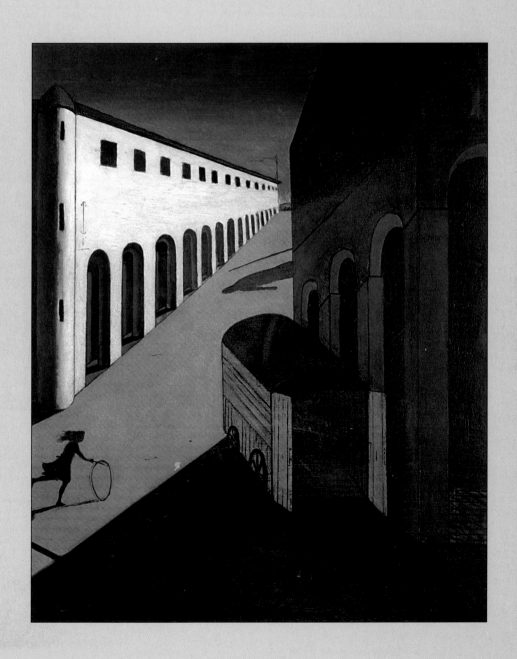

Their youth was marked in both cases by frequent changes of place, and by the effects of living in a series of cheap hotels.

Apollinaire went to school in Monaco, Cannes and Nice, spent time with his family in Aix-les-Bains, Lyon and Paris without putting down roots, and lived in Stavelot, a small village in the Ardennes. In the meantime his mother, an inveterate gambler, tried to earn a living for herself, the two children and her new lover in the casino at Spa, Belgium – culminating in a nocturnal escape from unpaid bills. Later, Apollinaire was tutor for a time to a family near Bad Honnef, Germany, whence he travelled to Prague, Vienna and Munich. Then he followed his first great love, an English governess, to London. In Paris from about 1902, still seeking shelter under his mother's wing, he tried to make a living at various occupations and have his first poems published.

The young de Chirico travelled with his mother and brother from Athens via Corfu to Venice and Milan, attended the Munich Academy for almost three years, then went to Milan via Florence. Finally, after a short stay in Turin, he arrived in Paris on 14 July 1911, the French national holiday.

Both men volunteered for military service after the outbreak of World War I, Apollinaire in Nice or Nîmes in autumn 1914 and de Chirico, with his brother, in May 1915, after Italy entered the war, in Florence or Ferrara. Both – as de Chirico describes in some detail in his memoirs – were driven by the same wish: to belong somewhere, to find a home of sorts, to establish their own identity. For Apollinaire, who was stateless, military service represented a chance to acquire French citizenship at last. He felt like a Frenchman, even though his papers long identified him as Russian. As many witnesses have testified, Apollinaire was a more or less enthusiastic soldier, and he remained so until the end of the war, despite serious wounds, to which we shall return later. De Chirico, on the other hand, took refuge in various nervous disorders, and during the war years was to be found more often as a patient than a medical orderly at Villa del Seminario in Ferrara.

Both Apollinaire and de Chirico read a great deal – Apollinaire tending to prefer novels and old chivalric romances, and de Chirico philosophy. Both men were conversant with Greek mythology, and Apollinaire with Celtic and Teutonic legends as well. Both felt they were misunderstood and unloved – Apollinaire once called himself the *mal-aimé*, the unloved. Both were driven by a strange restlessness, enjoyed mystery and mystification, and had an inclination to the occult. They believed in omens and were fascinated by magic in every shape, sometimes even claiming that they possessed

Guillaume Apollinaire:
Sketch after de Chirico's portrait of him, on *Les Soirées de Paris* letterhead
Private collection

Pierre Roy:
Woodcut based on de Chirico's
*Portrait of Apollinaire*,
for a collection of poems by Apollinaire
Woodcut, 20 x 14.5 cm

prophetic gifts, or at least hinting as much. In Apollinaire's poems and stories, whose origins in Symbolism were initially quite obvious, the heroes constantly meet magicians, soothsayers, gypsies, fortune-tellers. The great magician Merlin is invoked, as is the prophet Tiresias, and many variations are rung on theme of the poet as seer.

De Chirico, too, in the early Paris writings of 1911–15, speaks of the importance of premonitions, describes the mysterious language spoken to him by a statue in a shattered temple, and hints at his own prophetic powers. As he launched into metaphysical painting, he not coincidentally invoked *The Enigma of the Oracle*. In 1915 – shortly after the *Portrait of Guillaume Apollinaire* – he painted *The Seer*. De Chirico's titles frequently allude to predictions, riddles, enigmas, wise men's prophecies, and many of them reflect the influence of his friend Apollinaire. The eyes of his *Seer* are closed – like those of the man with a moustache in *The Brain of the Child*, 1914, or are concealed by dark glasses, like the bust in the *Portrait of Apollinaire* or in *The Dream of the Poet*, which also dates from 1914, and was probably executed concurrently with that portrait. Sometimes the visionary figure has a star on his forehead like an eye, like the faceless *manichino* on a plinth, which de Chirico expressly designated *Prophet* or *Seer*. André Breton was later to share the two men's enthusiasm for magic, mystification and the occult.

To locate Apollinaire in literary history, the lyric poet of *Alcool*, 1913, and *Calligrammes*, 1918, would have to be placed somewhere between Rimbaud and Eluard. Apollinaire the dramatist, with his stage play *Les Mamelles de Tirésias*, premiered in Paris in

Raoul Dufy:
*Orpheus Enchanting the Fish* (detail). Woodcut illustration for Apollinaire's *Le bestiaire ou cortège d'Orphée*,1911

*Portrait of Apollinaire*, dedicated to Guy Romain (Paul Guillaume), spring 1914
Ink and pencil, 21 x 21.5 cm
Private collection

*Léopold Survage, Hélène d'Oettingen, Pablo Picasso,and Serge Férat at Table*, winter 1914–15

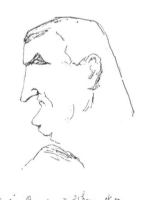

1917, earned a place between Alfred Jarry's *Ubu Roi* and Antonin Artaud's *Theatre of Cruelty*. But with regard to his closeness to the artists of the day, his passionate interest in the way their work developed, and his more enthusiastically subjective than critically objective reviews (which provided a good proportion of his sparse lifetime income), Apollinaire ranks with two other major poet-critics, Baudelaire and André Breton. Apollinaire's fame as a poet cannot be separated from his links with the avant-garde in art. Rousseau, Chagall, Marie Laurencin and Picasso dedicated paintings to him; Derain and Dufy illustrated his books, or provided drawings to accompany them. Hardly anyone else on the Paris art scene had his portrait painted so often as Apollinaire. He held a central place there, and commented regularly on its happenings. From 1907 he contributed to *Paris-Journal*, *L'Intransigeant,* and

*Mercure de France.* In 1910 he became regular correspondent for the Salons and galleries for *L'Intransigeant*. Then, with the aid of wealthy friends, Apollinaire in 1912 established his own standard-setting avant-garde journal – *Les Soirées de Paris*. Yet despite the enormous curiosity with which he followed all the goings on between Montmartre and Montparnasse down to the last intrigue, despite his eloquent commitment to new art in all its manifestations, it was Apollinaire's growing fame as a poet – or more precisely, poetic renown combined with critical influence – that determined his stature and sparked the legends that grew up around him early on.

*Calligrammes 230*
Illustrations for Apollinaire's *Calligrammes*, published by Gallimard, Paris, 1930
Lithograph, 15.5 x 15.9 cm

*Calligrammes 145*
Lithograph, 15.3 x 15.6 cm

From 1908 onwards, Apollinaire published a volume of poetry or prose almost every year. A first collection of his new poetry, later to be called *Calligrammes*, was to have appeared in 1914, with a frontispiece by de Chirico. He planned to call it *Et moi aussi, je suis peintre*, a title that, again, was intended to emphasize his links with the painters around him, who he felt embodied the creative element of the era more than anyone or anything else. (For a later edition of *Calligrammes,* published in 1929, de Chirico would produce no fewer than 66 lithographs.) The idiosyncratic typographical form Apollinaire gave to many of his poems, evoking figures and objects, underscored his role of a Renaissance man who was equally at home in the fields of painting and poetry, and was able to combine the two harmoniously. This synaesthetic ambition was also reflected in the term 'Orphism,' coined to describe his friend Delaunay's art.

*Calligrammes 124*
Lithograph, 15.3 x 16 cm

*Calligrammes 116*
Lithograph, 15.8 x 15.8 cm

The portraits done by his artist-friends accordingly show Apollinaire as the hub of a circle of creative minds. Like a high priest of art he sat enthroned in his little attic flat on Boulevard Saint-Germain, presided over the meetings of a group of artists and intellectuals that included Picasso and de Chirico, Derain and Max Jacob, Picabia, Archipenko, Paul Guillaume, Pierre Roy and Marie Laurencin, who was Apollinaire's partner from 1907 to 1912.

Yet no portrait was associated more closely with Apollinaire by his contemporaries and especially later generations than that by de Chirico. None of the others – including Rousseau's – exercised such a strange and lasting fascination. When Edition Gallimard

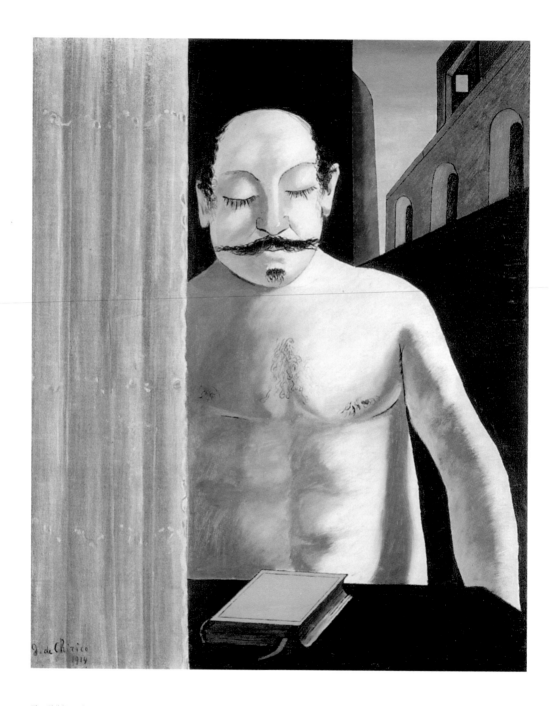

*The Child's Brain*, 1914
Oil on canvas, 81.5 x 65 cm
Moderna Museet, Stockholm

published Apollinaire's collected art criticism from 1902–18 in 1960, they reproduced this image on the cover. It also adorned the cover of the German-language edition of *The Painters of Cubism*, a small selection of his Salon reviews made by the author himself and published in 1912. This is all the more remarkable for the fact that de Chirico does not figure in the book – he could not be called a Cubist by any stretch of the imagination. Then, too, Apollinaire had not yet met him when he collected these essays in 1912. Yet today, it seems impossible to think of Apollinaire without seeing a mental image of de Chirico's portrait.

Apollinaire actually wrote much more frequently and in considerably more detail about many other artists – especially Picasso, Rousseau and Marie Laurencin, as well as Delaunay, Braque and Duchamp – than he did about de Chirico, even though the Gallimard edition of the *Chronique d'Art* and its German version contain only a fraction of Apollinaire's scattered remarks about de Chirico. Much of what Apollinaire noted on his tours of the Salons, where several thousand pictures and sculptures vied for attention, tends to seem casual, banal, and occasionally interchangeable. But his comments on de Chirico are always extraordinarily precise and carefully considered, which suggests that the two must have been in close personal touch by 1913–14.

Apollinaire's reviews were always produced under considerable time pressure. Many have the breathless quality of writing to meet a deadline. Also, he much preferred anecdote to analysis. Apollinaire's ideas about advanced art sometimes seem overly enthusiastic, and are often contradictory. He welcomes a whole range of different developments and tries to reduce them to a common denominator. Although he often recognizes their quality and standing, he misunderstands their tendency and implications.

Yet we also find inspired passages on Picasso, on Rousseau, and indeed on de Chirico. Especially in de Chirico's case, Apollinaire turned out to be a clairvoyant critic who recognized the essence of his art early on, as various reviews of 1913 and 1914 indicate. To cite only one example: "G. de Chirico constructs harmonious and mysterious compositions in the midst of harmony and meditation."

Let us take a closer look at de Chirico's *Portrait of Guillaume Apollinaire*, which was painted at precisely the time that Apollinaire wrote the above lines. Two misunderstandings or confusions that have dogged discussion of the picture from the outset need to be addressed. Firstly, the portrait of Apollinaire is found in the shadow or silhouette against the green sky at the top. Only with reservations can the classical bust in sunglasses be called a portrait.

And secondly, this statue was probably not intended to represent Apollo, as many commentators have assumed. Apollinaire was not Apollo, not a god, but at most a demigod. The hero he himself identified with was Orpheus.

This mistaken identification of the poet's portrait with the statue and the statue with Apollo are just two of the misinterpretations to which the picture has always been prone. Doubts have even been expressed whether it was a portrait of Apollinaire at all. The profile drawing of the poet that de Chirico made in 1914, cited here to authenticate the portrait, has also been treated with scepticism. The reason for this was the dedication inscribed along the bottom edge: 'A Guy Romaine.' It was addressed to Paul Guillaume, who used the pseudonym Guy Romaine. The dedication translates in full: "For Guy Romaine, the man and art patron, [this] metaphysical gift of friendship and tranquil recollection 1914 Giorgio de Chirico." Now, de Chirico portrayed Paul Guillaume in two oils and at least one drawing, and we know that he did not bear the slightest resemblance to Apollinaire, either full face or in profile. De Chirico perhaps intended to meet a different obligation by presenting his drawing of Apollinaire to his art dealer Guillaume, on whose friendship and good will he depended. In any case, the portrait and the dedication to Paul Guillaume are associated with another Guy Romaine or Guy Romanus – Guillaume Apollinaire, who was born in Rome – an allusion entirely in keeping with de Chirico's taste for mystification.

De Chirico's *Portrait of Apollinaire* is composed like a collage. It consists of four sections that are set against each other contrapuntally. The light-coloured vertical area with its graphic forms stands out from the coloured background and the black shadow. The two-dimensional treatment of the portrait silhouette and the dark archway on the right, contrasts to the three-dimensionally modelled bust – evidently a plaster cast of a marble original. More heterogeneous, even jarring juxtapositions would be hard to imagine. The composition is held together neither by uniform perspective nor by a consistent painterly treatment of details. These clash harshly and irreconcilably, evoking a fragmented and alienated world. The exaggerated, Cubist perspective of the space on the left seems to lead precipitately to infinity. This effect is counteracted by the arch of the arcade, which helps to reintegrate the composition.

The silhouetted head with a bull's-eye on its temple recalls a target in a shooting-gallery. In contrast to its lifelessness, the face of the plaster statue in sunglasses seems embued with a secret life – isn't there even a smile playing around his lips? And so, formally speaking, this is a work that is entirely in tune with its times.

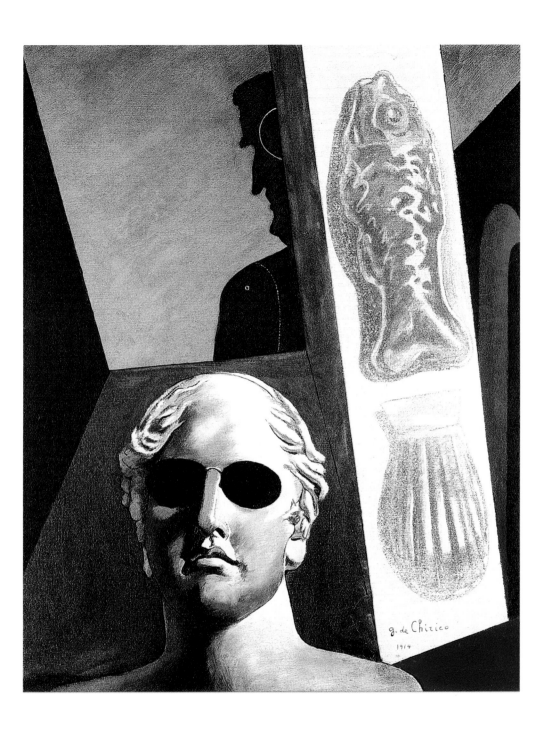

*Portrait of Guillaume Apollinaire*, 1914
Oil on canvas, 81.5 x 65 cm
Musée d'Art Moderne,
Centre Georges Pompidou, Paris

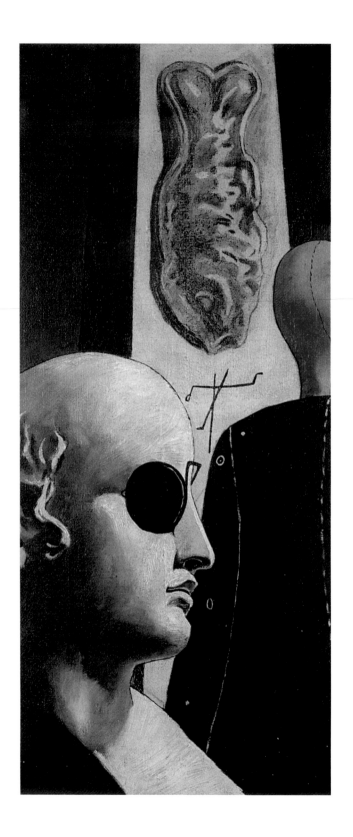

*The Nostalgia of the Poet*, 1914
Oil on canvas, 89.7 x 40.7 cm
Peggy Guggenheim Collection,
Venice

Experiences drawn both from Cubism and Orphism are applied; the interplay between plane and space, figure and ground, could not be more impressively handled. In addition, it would be hard to conceive a more radical fragmentation of context or collage-like intrusion of symbolic, graphic elements into a painting.

But it would be to misunderstand the picture completely to interpret it only as an invocation of an alienated world, referring to a contemporary poet who himself had invoked this world. The individual elements of the composition come together formally to create a contrapuntally determined whole which, rather than being organic or unified, can be characterized as constructive and complex. But this is not all. The apparently unrelated elements of the picture also form a whole in terms of content and iconography; they relate to each other, and at the same time they all relate to the personality of the subject, Apollinaire, as Maurizio Fagiolo dell'Arco has demonstrated in a masterly study.

Apollinaire is depicted in front of a plane of Veronese green – the colour de Chirico favoured for sky in his metaphysical period from 1910 to 1919 – as a black silhouette, a shadow, a cut-out, a shooting-gallery target. Two elements seem crucial here: representation as a shadow and designation as an *homme-cible*, a target-man. This was the same role in which the poet concurrently appeared in the writings of Alberto Savinio, de Chirico's brother, published by Apollinaire in *Les Soirées de Paris*. Both the shadow and the target can probably be traced back to the fairs of Montmartre, which attracted both Apollinaire and de Chirico for the same reasons. They featured a famous booth where Chinese shadow-plays were performed, roundabouts, swings, shooting galleries and other attractions, elements of which de Chirico cited in an alienated fashion in his pictures. Also, the shadow was stylistic device that de Chirico used from an early stage, as seen in *The Enigma of a Day and Mystery and Melancholy of a Street*, both 1914.

Like statues, plaster casts, tailor's dummies and frameworks of geometrical instruments, shadows are visual metaphors that indicate the apparent absence of human beings while definitely keeping a place open for them. Like the other metaphors, the shadow refers to the spiritual presence of someone physically absent, stands in proxy for him. It engenders a state of uncertainty, the ambivalence of presence and absence. Apollinaire, too, was partial to the image of the shadow, as can be seen from many passages in his poems.

But it seems to me that there is something more important here than this reference to his poetry. This is a visual experience

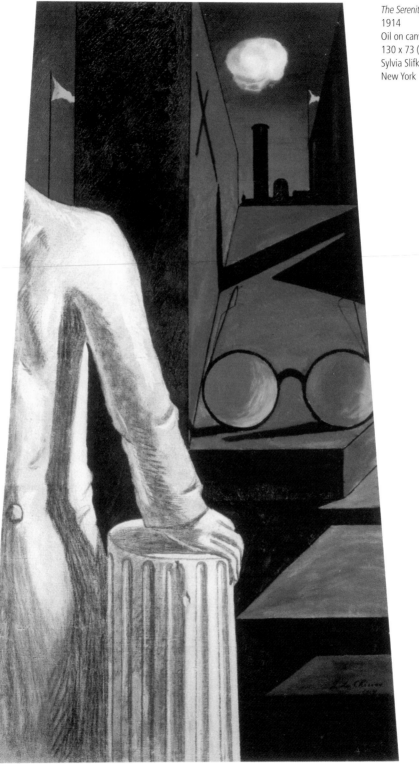

*The Serenity of the Scholar*,
1914
Oil on canvas,
130 x 73 (54.5) cm
Sylvia Slifka Collection,
New York

shared by de Chirico and Apollinaire, which went back to the evenings spent among friends in his home. De Chirico mentions this experience in his obituary for Apollinaire, written in 1918 and published in the Italian magazine *Ars Nova* shortly after his death: "When I remember his profile, like an image on a coin, which I superimposed on the Veronese sky of one of my metaphysical paintings, I think of the melancholy earnestness of a Roman centurion …. As if in a dream, I see a grey, six-storey building in front of me, and right at the top, under the roof, two rooms. The curtain rises, and a picture of wonderful intimacy silently appears: Between the tragic innocence of the varnished images by the painter-douanier and the metaphysical architecture of the undersigned I see the light of a paraffin lamp, cheap pipes, stained yellow with nicotine, long bookshelves of white wood, heavy with books, and friends sitting silently in the shadows …. There, as if under the beam of a magic lantern, the fateful and gloomy rectangle of a Veronese sky begins to appear on the wall, and against that sky, the curving outline of the profile of the sad centurion reappears …. It is Apollinaire, Apollinaire returning. It is the poet and friend who defended me on earth, and whom I shall never see again."

*The Red Tower*, 1913
Oil on canvas, 73.5 x 100.5 cm
Peggy Guggenheim Collection,
Venice

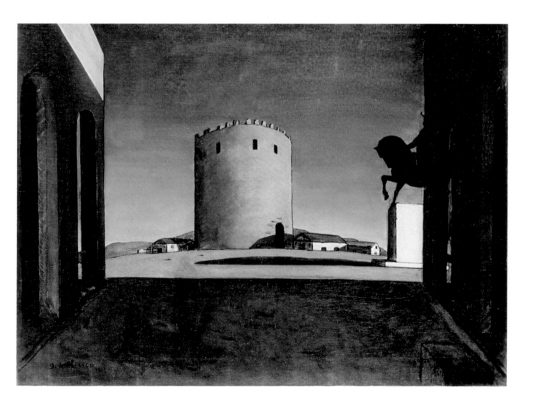

This suggests a new interpretation of the shadowy silhouette and the space around it: as the projection cast on a wall by a magic lantern. It may be that the memory of the paraffin lamp and the shifting shadows it cast in Apollinaire's room triggered this association. Or it may be a reminiscence of photographs taken with a flash, something that indelibly imprinted itself on de Chirico's memory. He once referred to flash photography as a 'discovery' that 'illuminated the camera obscura of my consciousness with a nocturnal flash of lightning.' Given this, the box-like housings with their extreme perspectives, found in many of de Chirico's pictures at the time, like *The Serenity of the Scholar* and *Still Life, Turin 1888*, both 1914, which initially suggest strangely distorted views from windows, might be interpreted as projections from a magic lantern. This would identify a revolutionarily new formal element in de Chirico's early pictures.

The other particularly interesting feature of Apollinaire's shadow profile is the inscribed bull's-eye. It is placed precisely at the point on the temple where Apollinaire was wounded two years later by a piece of shrapnel from a grenade that penetrated his helmet. After an operation to remove several small metal splinters, Apollinaire's condition temporarily improved, and he was fit to be moved to a Paris hospital. Although his wound healed, he suffered from fainting fits and symptoms of paralysis, and so two months after he was wounded Apollinaire had to have a skull operation, a

*The Song of Love*, 1914
Oil on canvas, 73 x 59.1 cm
The Museum of Modern Art, New York, donated by Nelson A. Rockefeller

*The Arch of the Black Ladders (A Hand's Breadth of Black Network)*, 1914
Oil on canvas, 62 x 47.5 cm
Private collection

trepanning. He recovered slowly. From then on Apollinaire, detailed to desk duties in a ministry, appeared in public in uniform and with a bandaged head. This is how Picasso depicted him in several drawings, and how various of his artist-friends depicted him again and again. Sometimes a poet's laurels adorned the bandage, as in a work by Irène Lagut, and one done a quarter of a century later by Alberto Savinio. This is the image of Apollinaire that we remember, and his early death on 9 November 1918, which was not entirely due to his head wound but probably more to the general weakening of his once robust constitution, now no longer able to resist the terrible postwar pandemic of Spanish influenza – this premature death also cemented the identification of the avant-garde poet with the image of the wounded hero who died young.

Apollinaire viewed himself in a similar way. A cruel, sacrificial death is a recurrent motif in his writings. Merlin, the magician in *L'Enchanteur pourrissant* (The Decaying Magician), dies such a death – if without entirely losing his magic powers, which still work from beyond the grave. The hero of Apollinaire's novel *Eleven Thousand Rods*, Mony Vibescu, dies this death, and is thus redeemed from his passion. The autobiographical elements are even clearer in the prose work *Le Poète assassiné*. Croniamantal, the protagonist of the episodic narrative, is torn to pieces by an angry mob like Orpheus by the Maenads in the myth. He falls victim to his times, in which all poets are to be killed because of a campaign by a devilish adversary that has caused poets to be seen collectively as criminals, and persecuted. This text was finished by 1914, and Alberto Savinio reports that Apollinaire was reading the proofs at the time de Chirico was painting his portrait. However, much as in the case of *Calligrammes*, publication was delayed. The volume finally appeared in early May 1916 – the very day on which Apollinaire was being trepanned – now with a final chapter called 'The Poet Resurrected' and with an up-to-date cover showing Apollinaire as an infantryman on horseback, bleeding from a head wound.

The idea of a wound as the stigma of an archetypal figure also entered his poetry. "A star of blood will crown me for ever," reads a line from 'Mourning for a Star,' a poem Apollinaire included in the last group of *Calligrammes*. He was still alive when these were published in 1918. "This almost fatal hole – star on my forehead," we then read, and this sequence of poems aptly bears the title 'The Starred Head.' One might even say that from this point onwards, Apollinaire was sustained by his wound, and found his ultimate identity as an 'assassinated' and 'resurrected poet.' He was Orpheus, who descended into the underworld and returned.

# Giorgio de Chirico
## *Still Life: Turin 1888*, 1914

*Still Life: Turin 1888* seems to have been constructed with a ruler.
The composition is determined by a series of irregular triangles,
rectangles, trapezoids and their shadows, which evoke a completely
ambiguous pictorial space. Straight lines intersect like fleeting
diagonals, opening up a trapezoidal stage that recalls a window
sill extended far outside and bearing a number of discarded, empty
window frames.

A few solid geometrical bodies lie on this stage: a cylinder, a
section of a disc, an ovoid structure sitting on a flattened pyramid,
like the snail shell on a snail. These objects are difficult to define,
and painted with coloured stripes as though they were children's
toys. The stage-like area ends before the empty shell of a building,
set in the space counter to perspective, whose cavernous empty
windows raise intriguing questions. The middle object, a cylinder,
placed a little below the centre of the picture, presents its base to
view. This circle is divided into four sectors. Two of these bear in-
scriptions: 'Torino' in the left-hand sector, and in the right, a date –
and a horse's head.

De Chirico was born in 1888, the year in which Nietzsche dis-
covered Turin as the "first town in which I am possible." For the
philosopher, Turin in 1888 brought the final, radical intensification
of his life's work, yet it also became the site of disaster – it was
here, at the turn of the year 1888–89, that Nietzsche succumbed to
mental derangement. An incident signalled the onset of madness:
Nietzsche stayed the whip of a coachman who was mistreating
his horse and embraced the poor animal with tears streaming down
his face.

No other city left deeper traces in de Chirico's work than Turin.
Its spacious squares and long arcades, its proud monuments and
austere architecture shaped his vision of an ideal Piazza d'Italia,
ever-new variations of which he developed in Paris in the years
1912–15. De Chirico knew Turin from two brief visits. He stopped
there once when he was moving from Florence to Paris with his
mother in July 1911, and then spent precisely ten days there in
early March 1912, after coming from Paris to volunteer for the
Italian army (only to immediately desert it again). But apart from

*Still Life: Turin 1888*, 1914
Oil on canvas, 60 x 46 cm
Rolf Weinberg Collection, Zurich

personal biographical links, Turin was the city of Nietzsche for de Chirico, where the philosopher he most admired wrote his most triumphant works (such as *Ecce Homo*) and went through his bitterest hours.

One object – located right under the truncated cylinder with its inscription and horse's head in the middle of the picture – is especially intriguing. It has the shape of an egg, light pink with black dots, and strongly suggests a fossil. The iconography of the egg revolves constantly around ideas like birth, coming into being, life. When petrified, it also includes death, thus containing birth and death in a single symbol.

*The Double Dream of Spring*, 1915
Oil on canvas, 56.2 x 54.3 cm
The Museum of Modern Art, New York,
James Thrall Soby Bequest

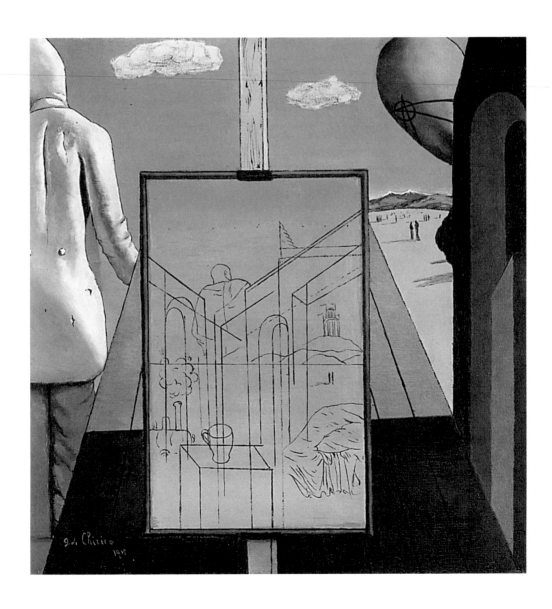

A piece of earthly immortality seemed assured him. And it was in this very role that de Chirico depicted his friend from memory, in 1942, as Orpheus with lyre and laurel wreath, at a time when his original source of inspiration had long run dry. This painting openly states what the artist had previously only covertly evoked: the poet's fatal secret. Like Orpheus, he was predestined to suffer a fearful death.

We can assume that when he painted Apollinaire's portrait, de Chirico was familiar in essence with *Le Poète assassiné,* from the manuscript and proofs, from readings or from conversations with Apollinaire. But it would be nonsense to seriously suggest that he foretold the precise spot of the poet's wound with the bull's-eye on the figure's temple. He certainly did not have prophetic gifts of the kind later attributed to him by the Surrealists on the basis of this portrait, however much he loved toying with premonitions and prophecies, magic and riddles, and surrounding himself with an air of mystery, and however much he humoured the temperament of his friend Apollinaire by doing so.

When de Chirico portrayed Apollinaire with a target or bull's-eye on his forehead, he may been alluding to the fate of Croniamantal as described in *The Poet Assassinated,* or he might have been using a clearly intelligible metaphor for the attacks directed at Apollinaire from 1911 onwards. These began in the wake of the affair about the theft of the *Mona Lisa* from the Louvre, for which he had been detained in investigative custody at the Santé. This interval was followed by accusations of pornography, aimed both at the author of the novels *Eleven Thousand Rods* and *Heroic Deeds of the Young Don Juan,* both dating back to 1907, and at the editor of de Sade, who had brought the notorious marquis's writings back into the public eye in 1909.

Or de Chirico might have been thinking of the two duels in which Apollinaire was involved in spring 1914, which threatened to make him into a real target. He had challenged Arthur Cravan, a future Dadaist, for obscenely insulting him, and also had a falling out with with a painter who felt badly treated by the critic. On the whole, the target on the figure's head might be seen as a general reference to the many attacks made on Apollinaire as an unwelcome foreigner who deigned to interfere in French affairs.

Xenophobia was by no means unknown in right-wing circles even in pre-war Paris, and Apollinaire was not granted the French citizenship he craved until spring 1916, at the time he was wounded in action. When de Chirico portrayed him, Apollinaire was as controversial as a man as he was as a poet, and as a poet no less than as a critic who championed the avant-garde. So it was

certainly not far-fetched to depict him as a target, even though de Chirico naturally did not want him to be actually hit. What appears here is merely a shadow of Apollinaire, a cardboard figure, a shooting-gallery target. The light from the magic lantern barely reaches the poet. He remains concealed in the pervading darkness.

Another shadow echoes the disc on the shadow's temple – the curve of the arch at the extreme right of the picture. The arch refers to Apollinaire as well. We have seen that de Chirico called Apollinaire a 'Roman centurion,' and this was not simply because he came from Rome. As the artist's 1918 text continues, the centurion "enters the ship's bridge that extends to the shores of conquered lands. …" Yet for de Chirico, Rome was inseparably linked with the image of the arcade, and arcades signified mystery, fate, predestination. In early text, written in Paris about 1911–12, de Chirico says: "There is nothing comparable to the enigma of the arcade, invented by the Romans. A street, an arch …. There is something fateful about a Roman arcade. Its voice speaks in riddles full of strangely Roman poetry. Shadows on ancient walls and a strange music of deep turquoise, like an afternoon on the seashore."

If the arcade is an attribute of Apollinaire, the two graphic symbols seemingly affixed to the narrow end of a wall, baking moulds in the shape of a fish and a seashell, are attributes of Orpheus. We know that Orpheus accompanied the Argonauts, whose journey, the legend says, began in Volos, de Chirico's birthplace – reason enough for his lifelong identification with them. We also know that Orpheus saved the Argonauts from all manner of misfortunes and dangers by the power of his singing. His songs enchanted the fish, who peacefully accompanied the ship, leaping rhythmically into the air.

The lyre Orpheus played was made from a tortoise's shell or a seashell – de Chirico's version of the shell clearly suggests associations with a lyre. Apollinaire was no less familiar with the attributes of Orpheus. In 1911 he had published a sequence of poems called *Bestiary, or the Retinue of Orpheus,* with woodcuts by Raoul Dufy. Dufy likewise pictures Orpheus with his lyre, fish following and gamboling around him, and in the background the Argo and the Sirens, whom his singing has also pacified. Apollinaire was just as familiar with the joyful side of Orpheus, taming wild animals and overcoming danger, as he was with his tragic side – his fate at the hands of the Maenads, who tore him to pieces. "All poets were, like Orpheus, close to a wretched end," he wrote in *Le Poète assassiné,* and went on to invoke a vision of plundered publishing houses, burned books and persecuted poets. There is a strange irony of history – or should we call it a prophecy – in the fact that

*The Astronomer (The Anxiety of Life)*
c. 1915
Oil on canvas, 40 x 32 cm
The Menil Collection, Houston

*Still Life: Turin Spring*, 1914
Oil on canvas, 125 x 102 cm
Private collection

on the eve of World War I, Apollinaire sees these book-burnings, these persecutions of poets and these massacres as originating in Germany.

The fourth section of the picture shows a plaster cast of a classical statue. It reminds many people of the *Apollo Belvedere* in the Vatican Collections, which appears in a relief version in *The Song of Love*, also 1914. But here the allusion is not to the Greek god, but much more probably to Orpheus, one of the heroes of antiquity. Orpheus was the son of the King Oeagros of Thrace and the Muse Calliope. According to tradition, Apollo was his divine father, and certainly the god taught him to play the cythara, which he later gave to him permanently when Orpheus had learned play it perfectly. De Chirico's image of Orpheus also distantly recalls his divine origins, of his tutelary god and godfather Apollo. But then we have the pair of dark glasses that alienates the portrait of the hero. These remind us of the complex nature of Orpheus, which according to myth combines both light and darkness – but in a state of eternal conflict, rather than mutual reconciliation. The fish, the prime attribute of Orpheus, was the creature that was perhaps most enchanted by his music, as we know from the journey of the Argonauts. Mythologists always associate the fish with light, and some expressly with eyesight, the light of the eyes. In de Chirico's picture the zone in which the fish and the shell – as a metaphor of love – appear is the brightest source of reflected light. It casts a dazzling glow on one side of the statue, leaving the other, the left side, in shadow.

Alberto Savinio defined Orpheus as the bringer of light and truth, using etymological speculation to derive his name from the Phoenician terms for light and healing. But the mythologist Karl Kerenyi thinks that the name comes from *orphne*, which means darkness. Both elements, light and darkness, death and resurrection, come together and struggle for supremacy in the myth of Orpheus and Eurydice. Orpheus descends into the underworld to bring Eurydice back to earth. He finds his way through the darkness of Hades without difficulty, reaching Eurydice unchallenged. His singing and lyre playing overcome all barriers and show him the way. He is allowed to take Eurydice away on one condition: he is not allowed to see her. He must not look at her until they have both returned to the light of the world. So Eurydice follows him back up into the world. When Orpheus steps into the sunlight at the end of the dark passage he turns round and sees Eurydice behind him – a moment too soon, as she is still in the dark. So Hermes, the guide to the souls of the departed, takes her by the hand and leads her back into the depths of the underworld.

De Chirico and Apollinaire may not have been aware of every detail of the speculations advanced by mythologists and psychologists – but they were surely familiar with the story of Orpheus and Eurydice. Light can allow us to see, being essential to the manifestation of phenomena, but it can also be dazzling: "I love the art of today's painters," wrote Apollinaire, "because above all I love light." But he has his protagonist Croniamantal, the murdered poet, the reincarnation of Orpheus, say shortly before his death: "I have often seen God face to face. I have withstood the divine radiance that weakened my human eyes." Croniamantal was on the path to illumination, but the light was too strong for him, threatened to immolate him.

And another antagonism comes into play here as well. It no longer involves Orpheus, but another mythological figure, the blind prophet Tiresias. When de Chirico painted his portrait of Apollinaire, Apollinaire was not just working on the text of *Le Poète assassiné,* but was also planning what he called a surrealist drama, *Les Mamelles de Tirésias* (The Breasts of Tiresias). Apolliniare was not to complete this in its final form until after he was wounded, and it was not premiered until June 1917. Apollinaire shifts two elements of this myth into a surreal present: As Thérèse changing sex to become Tiresias, and then back again, via the figure of a fortune-teller and prophetess, to become the housewife Thérèse again. In the Greek myth it was Zeus who changed Tiresias into a woman for a while, possibly as a punishment, possibly as a game, a joke played by the gods, so that he could see what it felt like to be a member of the opposite sex. Apollinaire uses the fortune-teller to identify the capacity that Zeus gives to Tiresias to compensate him for his blindness – no longer being able to see in the present, he is granted the power to see into the future.

What we have, then, is a complex game with light and darkness, blindness and prophecy, deception and insight, that can be played almost ad infinitum. Apollinaire provided a number of variations on it in his poetry. De Chirico also found it a source of constant fascination, on the one hand as a compositional device for building up formal tensions, on the other as an element of content with which he could lead cognoscenti and adepts into a labyrinth of iconographic and mythical allusions.

At this juncture I shall risk launching my interpretation of the painting, as a double image of Apollinaire, as shadow and statue. His profile, an accurate portrait likeness, refers to the poet's present situation, if only in the form of a shadow or cardboard figure. Yet his embodiment in a statue or bust refers to a destiny that will last. In the present, Apollinaire is a target, exposed to his

*The Endless Journey*, 1914
Oil on canvas, 88 x 39 cm
Wadsworth Atheneum, Hartford,
The Goodwin Collection

opponents' attacks. But the future looks different, as it belongs to the realm of myth. The Apollinaire of the future is embodied in the figure of Orpheus, for this is how he will be remembered. As a statue he can no longer be attacked, and he is protected by his dark glasses from seeing what he is not permitted to see. He is armed for the experience of the underworld, shielded from the temptation to look back, so that he look within himself without distraction and thus become both figures, poet and prophet, for ever.

With this double portrait, Giorgio de Chirico caught the essence of Apollinaire more precisely than any other artist. The dominant theme of almost all Apollinaire's writings is the dual nature of man. His heroes and anti-heroes are sinners and saints in one, frauds and rulers, martyrs and criminals, opposing traits like those in his own personality. Though Apollinaire made amazingly bold innovations in his poetry, he still doubtless remained trapped in a traditional notion of beauty. He wrote a great deal, and yet weighed every word. He wallowed unreservedly in the excesses of pornography and at the same time he was capable of the most tender tones in his love poems, as in 'Pont Mirabeau.' He was an outsider in society from birth, and an undisputed high priest of criticism for the avant-garde. He was an active impresario and

*The Endless Journey* (detail), 1914
Oil on canvas, 88 x 39 cm
Wadsworth Atheneum, Hartford,
The Goodwin Collection

poet, he was an anarchist and a French patriot, and his nature harboured many other contradictions – not always harmoniously, as we know. De Chirico instinctively understood Apollinaire's complex character and added one more pair of contrasts to those already mentioned. By depicting the poet in a way typical of his metaphysical period, in his dual nature, but in encoded form – as target and statue, as a vulnerable victim and as an unconquerable hero – de Chirico raised a lastingly valid monument to Guillaume Apollinaire.

We know that Apollinaire liked the picture and immediately wanted to own it. He asked for its delivery in several letters. De Chirico promised it to him, but reneged for some unknown reason. Instead – perhaps to meet existing debts – he gave the portrait to his art dealer, Paul Guillaume, from whom it passed to the poet. Even so, Apollinaire honoured his agreement to dedicate one of his *Calligrammes* to de Chirico. Apollinaire must have recognized himself in the portrait in a special sense. Perhaps he saw it as a fulfilment of the lines from the volume of poetry *Alcools*, published in 1913, in which he had said prophetically: 'And I too, when seen from close up, am dark and dull…. I depart and will shine in the midst of shadows…. They build me gradually, like a tower is built ….'

# Act III
## *Les Soirées de Paris:*
## Enter the *Manichino*

The figure of the jointed doll without a face, which made its first appearance on the unique pictorial stage in de Chirico's painting in 1914, derived indirectly from literature. Its ancestry can be traced far back into the past. Of course the dream of creating an artificial human being has a long history, to which the Golem of the Kabbala belongs as much as E.T.A. Hoffmann's doll, Olympia. Still, the direct inspiration for de Chirico's tailor's dummy came from a literary work of his own day, the poem 'Le Musicien de Saint-Merry' (The Musician of Saint-Merry) by his friend Guillaume Apollinaire, which in turn inspired Alberto Savinio's dramatic fragment *Les Chants de la mi-mort* (Songs of Semi-Death). Willard Bohn, who has provided a brilliant study on the emergence and development of the *manichino* idea in de Chirico's work, compares the relationship between Apollinaire, de Chirico and Savinio with the corners of a triangle that were not only interconnected but mutually influential.

Apollinaire wrote his ballad 'Le Musicien de Saint-Merry' in late 1913 and published it in February 1914 in *Les Soirées de Paris,* of which he was editor. Alberto Savinio wrote his *Chants de la mi-mort* immediately afterwards, in spring 1914. These in turn were printed by Apollinaire in July of that same year, in what proved to be the last issue of *Les Soirées de Paris* (whose publication was interrupted by the war). At the same time, Apollinaire was working with Savinio on a stage version of his 'Musicien', to be performed as a pantomime in a number of American cities, on a tour organized and financed by Alfred Stieglitz. The piece was to represent a joint production by the friends associated with *Les Soirées de Paris*: text by Apollinaire, music by Savinio, sets by Francis Picabia, choreography by Marius de Zayas. Many of Savinio's ideas, which modified the figures in the plot, had been incorporated in this stage version of 'Le Musicien', which was finally, after a number of revisions, titled *L'Homme sans yeux sans nez et sans oreilles* (The Man without Eyes without Nose and without Ears). De Chirico's image of a *manichino,* too, relied more strongly on the revisions this character had undergone in his brother's work than on the figure of 'L'homme sans visage' introduced by Apollinaire.

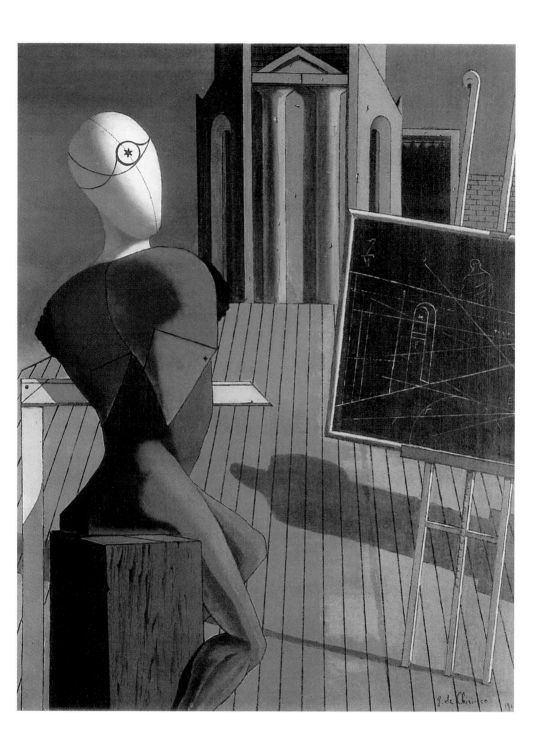

*The Seer (The Prophet)*, 1915
Oil on canvas, 89.6 x 70.1 cm
The Museum of Modern Art, New York
James Thrall Soby Bequest

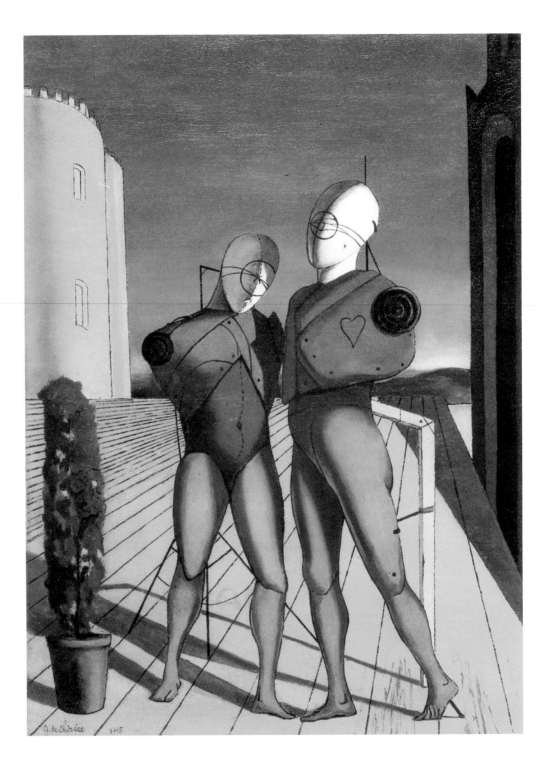

Another influence on de Chirico came from the sketches and designs that Savinio had prepared for a stage version of the *Chants de la mi-mort* (like Apollinaire with 'Le Musicien,' Savinio planned to put his work on stage). Both projects were abandoned on the outbreak of World War I. Savinio's maquettes, to which de Chirico admitted to owing a number of features – such as defining the tailor's dummy by visible seams – have unfortunately not survived, so it is impossible to determine the precise extent to which de Chirico's figure was anticipated by his brother's.

Although Apollinaire's musician lacked a face, he did have a crucially important organ – a mouth-like aperture above the neck. This was indispensable for playing his flute. And he played it so seductively that all the women in town involuntarily followed him down the street, like the children who followed the Pied Piper of Hamelin. The musician has been seen, on the one hand, as a phallic symbol, and on the other as an embodiment of ancient myth, a *mixtum compositum*, as it were, of Dionysos and Orpheus, of Pan and Thanatos. He led his followers (including Ariadne) into an abandoned building, where he disappeared with them as if they had dissolved into thin air.

Alberto Savinio stripped this 'Homme sans visage' of all phallic associations, and made him into a father figure called the 'Bald Man' (here translated into English):

> Man with no voice, without eyes and face,
> made of pain, of passion, of joy,
> he knows every game …
> he speaks every language ..
> and waits ….

The Bald Man has obviously returned from the realm of the dead, a 'revenant,' a ghost who now moves among the living.

> The dead man returns and sees himself dead;
> this black person passing by ….

The next scene takes us to a walled square in front of a building façade:

> Deep night, but the sky is blue.
> The Bald Man is stretched out on the ground.
> Rifle-target figures of tin
> are lined up against the wall ….

The mother is in an even worse state than the half-dead man, the revenant:

> Shrunken to a marionette
> the dear mother is petrified ….

The 'Yellow Man' – apparently the poet's *alter ego* – attacks her with blind fury in the 'Tower Scene':

> In a paroxysm of madness
> the Yellow Man hurls himself
> at his mother and kills her.
> The old woman shrivels,
> soon appearing merely
> to be a fat stone doll.

As the mother turns to stone, statues and monuments come to ghostly life:

> The statues in the lower section
> of the tower begin to move.
> The bronze horse bearing the king on its croup
> gallops on its pedestal.
> The king pulls at the reins.

In the final scene, accompanied by the flashing of a lighthouse, 'the Bald Man solemnly sings the song of the stars':

> I, man without a face, remain behind
> with the burden of my flabby flesh.

Yet he is still able to remember a strange amorous encounter:

> Come back, O you my SOMETHING
> of last night;
> you had an odd body,
> sad like a machine,
> complicated creature, strange animal,
> O woman! woman of my desire ….

*The Scholar's Playthings*, 1917
Oil on canvas, 89.5 x 51.4 cm
The Minneapolis Institute of Arts,
Minneapolis, donated by
Mr. and Mrs. Samuel H. Maslon

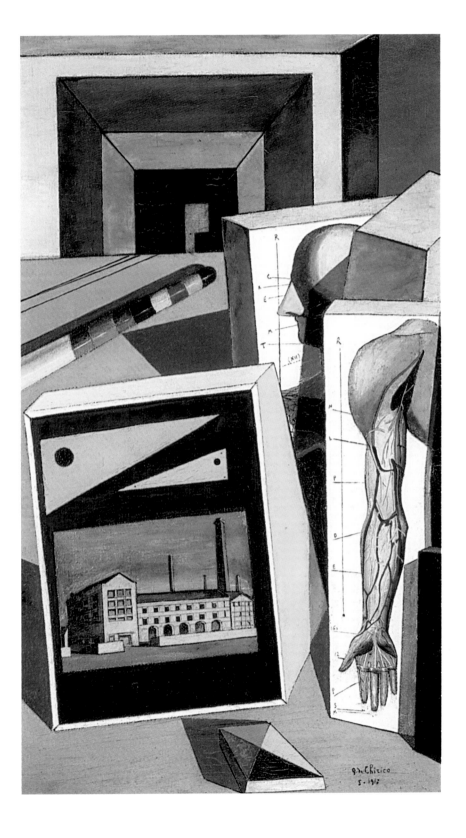

*The Uncertainty of the Poet,* 1913
Oil on canvas, 104 x 94 cm
The Tate Gallery, London

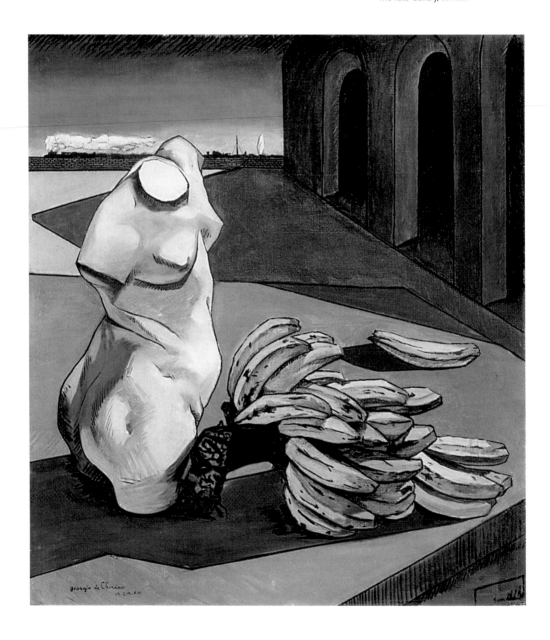

Then the Bald Man evokes the end of the world:

> The moment returns, hours of farewell …
> The statues set off on their way,
> marching in step,
> the fountains have dried up.
> On the huge, silent squares one sees
> steel guards patrolling up and down,
> the great machines mysteriously run
> without fire and without noise …
> and there is no wind blowing ….

It is easy to imagine how much these lines must have impressed de Chirico. They echoed much in his own experience and contained a number of elements found in his own pictorial language, from silent squares and equestrian statues down to the silent movement of the 'great machines' – his locomotives. This atmosphere, so familiar from his own metaphysical imagery, must have heightened his receptiveness to Savinio's idea of a 'man without a face,' who might well have struck him as a genuine ramification of his own statuesque figures.

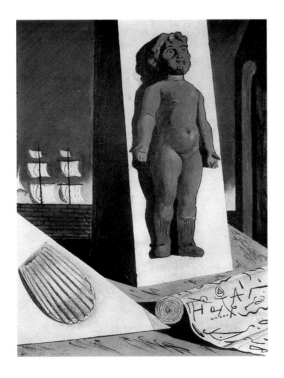

*Spring*, 1914
Oil on canvas, 35.5 x 27 cm
Private collection

# Giorgio de Chirico
## *The Philosopher and the Poet*, 1915

Like *The Duo* and *The Seer*, *The Philosopher and the Poet* was one of
the last pictures de Chirico painted in Paris in spring 1915. It was
probably started before the two others, in late 1914, but completed
after them (or perhaps not completed, judging by the sketchy, un-
finished appearance of the floor, walls, and a few other details).

In terms of conception, *The Philosopher and the Poet* is a counter-
part to *The Seer*. In each image, a *manichino* figure is shown con-
templating a blackboard covered with signs representing the riddles
and mysteries of the world in a nutshell. The blackboard is clearly
the figure's own work. For de Chirico, poet, artist and seer were
synonymous terms, by which he described his existence as a painter.
Gazing thoughtfully at the slate, the mannequin may be wondering
how far he has succeeded in outlining the universal mysteries – to
say nothing of solving them. Yet apart from the basic situation they
share in common, the two paintings differ in nearly every important
detail.
*The Seer* is posed on a stage, with a temple in the background re-
calling *The Enigma of an Autumn Afternoon*. *The Philosopher and the
Poet,* in contrast, are depicted in an interior – incidentally one of the
very first interiors in de Chirico's oeuvre. *The Seer* turns to face out
of the picture, fixing the viewer with the star on his forehead, while
the poet in the present painting is immersed in contemplation of his
slate – a 'picture within the picture' that represents the firmament
or perhaps stars reflected in still water. *The Seer* is alone on his
stage; the poet is accompanied by a plaster bust representing the
philosopher. The philosopher 'looks' in a different direction from the
poet-artist, no longer requiring empirical vision because he carries
the mysteries of the world within himself. For this reason the plaster
bust has no eyes. It is only the suggestion of hands folded on the
chest that indicates its orientation towards the viewer.

If the *Duo* of two *manichino* confront us with the brothers Gior-
gio de Chirico and Alberto Savinio in the role of the Dioscuri, surely
we can see father and son in *The Philosopher and the Poet*. But when
de Chirico invoked a father figure, as here, he usually meant not on-
ly his physical but his spiritual father: the philosopher Friedrich Niet-
zsche. Just as Mnemosyne, the goddess of memory, was the mother

of the Muses, in de Chirico's mind the philosopher was the father of the arts, above all of that art which aspired to the status of 'metaphysical.'

The mannequin's head is framed by a window looking out over the façade of a building that could be in an Italian piazza. But the figure has no eyes for the outside world. On the contrary, he is pondering over the signs on the blackboard, which stand for the firmament. The 'starry sky' of which Kant spoke is no longer above him. So he he lowers his head, perhaps listening to the inward voice that had been heard by Nietzsche, and that had earlier 'come down from the universal edifice' to the author Jean Paul – the voice that whispered, 'There is no God.'

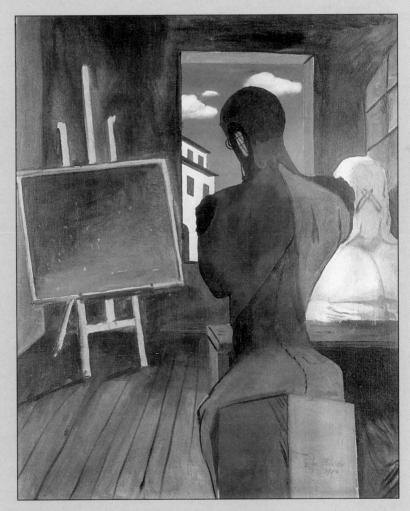

*The Philosopher and the Poet*, 1915
Oil on canvas, 82 x 66 cm
Private collection

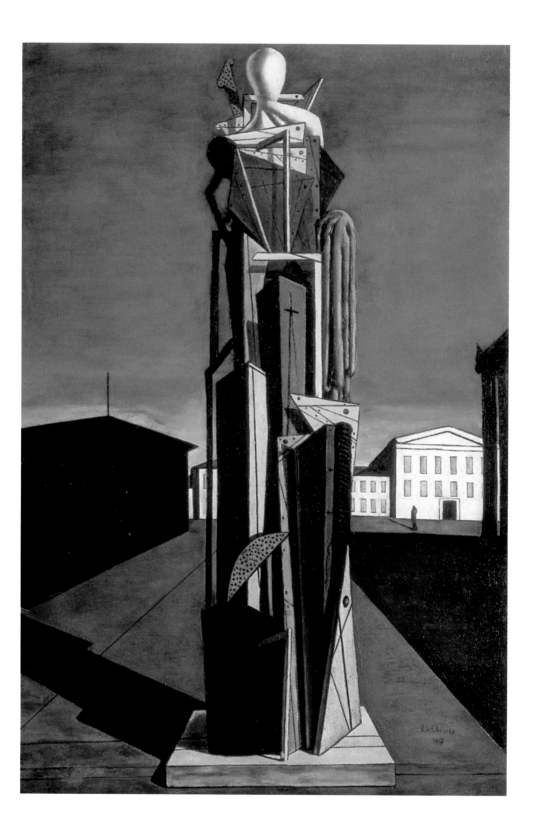

What must have especially intrigued de Chirico about Savinio's 'man without a face' was his ability, despite 'having no voice,' to sing, just as Apollinaire's faceless musician could play the flute. Didn't these figures possess the same arcane powers as the ancient busts that de Chirico depicted almost concurrently that spring, their eyes hidden behind dark glasses as if to redouble their blindness (*Portrait of Apollinaire* and *The Poet's Dream*)? Don't we associate these figures with the idea of 'inward vision' or prophetic 'second sight,' precisely on account of the blindness that prevents them from seeing the existing world?

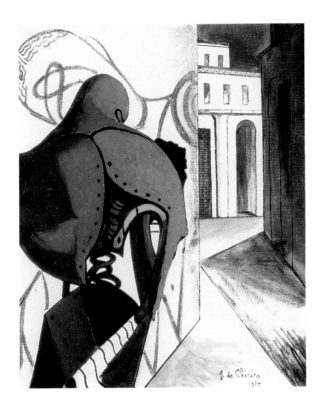

When de Chirico set out to give this faceless man the form of a tailor's dummy and incorporate him into his metaphysical imagery, he was helped – apart from Savinio's sketches for the planned staging of *Chants de la mi-mort* – by memories of *manichini* and the profound impression made on him by the papier mâché heads he had seen in the windows of wigmakers. As he noted in an essay called 'Zeuxis, the Explorer,' written in 1918 and published in the first issue of *Valori Plastici*:

"The great glove of coloured zinc with its terrible gilded fingernails that swung to and fro over a shop door in the dreary breezes of the afternoon town, directed me to the hermetic sign of a new melancholy, by pointing its index finger at the stone slabs of the pavement. The papier mâché head in a hairdresser's window, severed in the dubious heroism of dark, prehistoric days, seared my heart and mind like a recurrent song. The demons of the city were preparing the way for me …."

One trait of de Chirico's was crucial in encouraging him to link impressions from external reality – such as the mannequins and false heads seen in shop windows – with characters from literature (or their sketchily captured visual counterparts) and to reforge these into protagonists in his own painting. This was his inclination to see signs and omens relating to his own life wherever he

*The Deadly Light (The Inconsistence of the Thinker)*, 1915
Oil on canvas, 54.5 x 30 cm
Private collection

*The Great Metaphysician*, 1917
Oil on canvas, 104.5 x 69.8 cm
The Museum of Modern Art, New York,
Philip L. Goodwin Collection

looked. He felt deeply affected by them and compelled to translate them into artistic terms, in other words, to include them in his work in an altered and alienated form. De Chirico had always been concerned – obsessively and almost exclusively since his Ulysses picture of autumn 1909, *The Enigma of the Oracle* – to project personal experiences into ancient myth, lending them an encoded voice and at the same time the lustre of an objective reality. This allowed him to identify with the protagonists of his work, whether living figures or statues, without revealing anything about his own state of mind to the casual observer. It enabled him to hide behind his figures. His personal nature remained inaccessible to the inquisitive gaze, being concealed beneath the trappings of the figures or the stone of the statues.

The list of figures de Chirico drew from myth or poetry is a long one. Even in his earliest phase he was inclined – like his brother – to identify with the heroes of antiquity, with whom both had been familiar from early childhood. They were Argonauts who had set off from Volos – Giorgio's birthplace – to seek the Golden Fleece, and as brothers, they were the Dioscuri. Just as Giorgio painted Alberto dressed as Hamlet in 1909, he saw himself in the role of Ulysses, forever driven to new shores. Wearing these and many other masks, the two entered the realm of metaphysical imagery. Savinio, for his part, would conjure up the gods and heroes of ancient Greece, if in an ironically refracted way, in his own painting, begun in 1926, and in his literary texts, which included a play called *Capitano Ulisse*, written in 1925.

The list of mythical heroes with whom de Chirico identified is equalled in length by the list of guises in which his protagonists appear: Living figures, statues, shadows, busts, contour drawings, 'pictures within the picture,' and, from 1914, the famous *manichino*. As Paolo Baldacci has rightly asserted, the *manichino* was covertly present in the artist's work from the very beginning, as his *alter ego*, 'his double or doppelgänger,' despite its having initially taken a different form. In other words, the *manichino* occupies a place of prominence in the series of transformations to which de Chirico's alienated figure of identification was submitted. This series by no means came to an end after its first appearance. The figure was truly involved in an adventure without end, an 'Endless Journey.' Soon the tailor's dummy entered a new sequence of metamorphoses, beginning with that of an artificial troubadour – as in *Duo* – and and eventually culminating, in the Ferrara period, in the figure of the *Great Metaphysician*, made up of geometrical instruments, triangle and ruler, T-square and protractor, supplemented with doll-like set pieces.

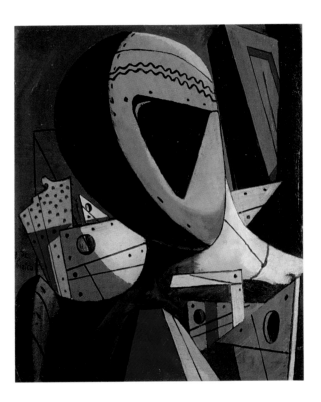

*Metaphysical Figure (Disquieting Muse)*
1918
Oil on canvas, 36 x 30 cm
Private collection

Just as de Chirico wished to express his gratitude and deep in-
debtedness to his poet-friend in the *Portrait of Apollinaire,* it would
seem reasonable to see *Duo,* which dates from about a year later,
spring 1915, as a sign of affection for his brother Alberto, and at
the same as a gentle but unmistakable hint as to who was the
greater artist. The picture shows two protagonists in an unknown
drama, facing each other on a stage set up between pink towers
and dark archways, and extending far towards the horizon. The
younger brother bows respectfully to the elder one, who stands
erect and aloof.

The two *manichino* troubadours are made of wooden parts and
upholstered and stitched pieces of fabric, and wear a protective
metal cuirass. The breastplate of the larger figure bears the outline
of his heart, which of course is actually concealed within. But there
is surely no harm in reminding us of its existence. Neither of the
figures has arms – they do not need them. Their activity is of a
purely intellectual nature. It is their ideas that affect and move us.
Yet as de Chirico indicates, the two *manichino*-troubadours do re-
quire some external aid, a supporting framework of metal rods or
strips of wood. This might be seen as a reference to their artistic

work, to the fact that it is a correlative of this work to which they owe their firm and secure position on the world stage.

If we pause at this point and look back at the way de Chirico's figures have developed since autumn 1909, their present shape appears extremely logical. And it would seem equally plausible that such figures should appear alternately in the form of statues and monuments or – like their female counterpart, Ariadne – in a form reminiscent of ancient sculpture. Classical Greek sculpture, which de Chirico was able to study in the Athens museum and the Glyptothek in Munich, held a unique attraction for him from an early age – as we know from his writings – as did modern monuments dedicated to outstanding personalities. Both sculptures and monuments embodied their subjects such as to show them as they were in life, even though they were long dead. The materials employed were equally inanimate. Whether marble or bronze, the statues appeared lifeless. And still, they evoked permanence, having been created for posterity, if not eternity. They denied the transitoriness of human life. They were in the world before we came into it, and they would still be there when we were long gone. Even though – or possibly because – they were not alive, these works of art would outlast us. The solidity of their material seemed to make them invincible. A strange immortality indeed.

This fascination with statues led to the painting that immediately followed *The Enigma of the Oracle*. *The Enigma of an Autumn Afternoon* was based on the often-mentioned vision the young de Chirico experienced in October 1909 on Piazza Santa Croce, in Florence, where he stopped on his way back from Rome to Milan. It suddenly seemed to him, in the 'light of a clear autumn afternoon,' as though he was seeing everything for the first time, detached from time and space. He was particularly moved by the statue of Dante that then still stood in the middle of the square, and that de Chirico placed in the centre of the image that immediately formed in his mind's eye on that October afternoon. In the painting, the piazza is much more constricted than in reality, displaced from its familiar surroundings and relocated by the sea, as indicated by the sail visible beyond the bounding wall. The statue, though still clad in a long, tunic-like garment like the Florentine poet's, now lacks head and lower right arm, and has its back to the viewer, and faces the sea. The pose is reminiscent of that of Ulysses in Böcklin's painting of Calypso's island. The figure from ancient myth and the medieval poet have been fused into one. Ulysses has become Dante, the living figure a stone statue. Yet it still seems to be pondering the same riddles as the wanderer on the rock by the seashore.

*Metaphysical Muses*, 1918
Oil on canvas, 54 x 34.5 cm
Private collection

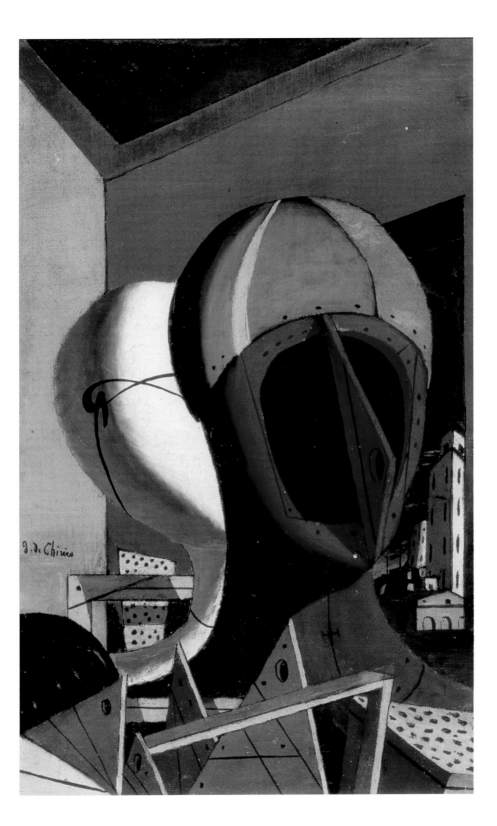

De Chirico probably saw several aspects that Dante and Ulysses shared in common. Not just that Dante was linked via Virgil to Homer and antiquity, but he appeared in his own epic poem in the character of a wanderer or pilgrim, seeking the infinite. Within the symbolic space of a week, Dante passed through the underworld cosmos of Inferno, Purgatory and Paradise, guided by Virgil and later by Beatrice. Ulysses, in ten years of wandering that took him to the most distant shores of the ancient world, gathered similar experiences on the face of the earth, indeed even being granted entry into the shadow realm below.

But we do not remember Dante just as a pilgrim and a poet. He was also involved in the vicissitudes of his day, as a politician and diplomat. De Chirico called this to mind when he shifted his statue from the timeless sphere into the modern world, and used it to represent  political figures, and soon, field marshals and kings on horseback. The toga (which the female *manichini* would later don) was replaced by a bourgeois suit, a tail coat, or a uniform. Paolo Baldacci insists that de Chirico believed influential political figures of his own day could have extraordinary qualities, and in exceptional cases, like those recalled by monuments, could be counted among the creative spirits. De Chirico even saw his own father as one such spirit. From childhood he idealized his father's activities as civil engineer and entrepreneur to the point of declaring him a 'constructor of new civil realities.' So autobiographical links may be recognized even in the regal monuments to political figures evoked in de Chirico's paintings of 1913 and 1914.

Ulysses may have slipped into the role of Dante and been transformed into a statue, but he also continued to appear in his original form, that of a human being brooding over his fate. This is how we see him in front of the temple in *Enigma of the Hour,* 1911, and the role he plays in relishing the *Joys of the Poet,* 1912. In *The Melancholy of a Beautiful Day,* 1913, Ulysses encounters the statue of the sleeping Ariadne – the anima, as de Chirico saw her, following Nietzsche – but he does not look at her. Both are entirely self-absorbed, she dreaming, he meditating. And then we come across Ulysses again, as a small accessory figure in the background of the *Great Metaphysician*, who finds himself in a piazza dedicated to another great Italian poet, Ariosto, in Ferrara.

Let us conclude by returning to the birth of the *manichino* and thus to the inspiring atmosphere of *Les Soirées de Paris* and the convocations in Apollinaire's studio in Boulevard Saint-Germain. The *manichino*'s first appearance was hesitant. In a picture with a strange title that is probably not de Chirico's own, *I Shall Be There –*

*The Enigma of an Autumn Afternoon*, 1909
Oil on canvas, 45 x 60 cm
Private collection

*The Delights of the Poet*, 1912
Oil on canvas, 69.5 x 86.3 cm
Private collection

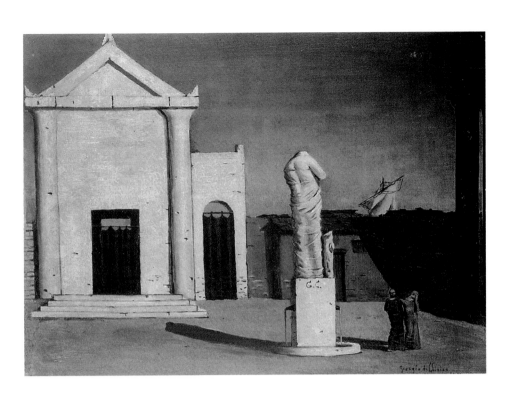

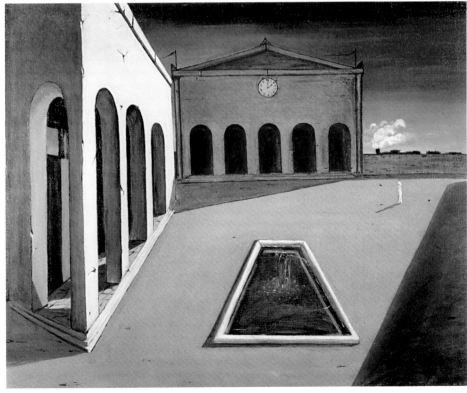

*I Shall Be There – The Glass Dog*, 1914
Oil on canvas, 69 x 67.5 cm
Private collection

*The Glass Dog,* April–May 1914, the *manichino* appears as a contour drawing on a black panel (alongside a female nude, modelled in the round in plaster, with her heart revealed). This outline drawing represents a literal translation of a statue leaning on a column, like that found in the immediately preceding painting *The Serenity of the Scholar.* The figure wears street clothes, with white dashed lines indicating seams – or the tailor's chalk marks – that illustrate the figure's metamorphosis from statue to tailor's dummy. Shortly thereafter the *manichino* figure would appear in the round – in *The Nostalgia of the Poet* – alongside the plaster cast of an ancient portrait bust wearing dark glasses. Yet here, too, the *manichino* still has its back to the viewer.

Then it turns round, revealing its face for the first time. In *The Endless Journey,* the dummy – now in female form – still appears as a 'picture within the picture,' rendered partly in painterly and partly in graphic terms. Perhaps the female figure is merely a dream dreamed with open eyes by the head of the smashed plaster statue. Or might she, rising triumphantly above the towers in the window, be preparing to rule the world?

From this point on the *manichino* figure faces us, enabling us to make a strange discovery. As expected, its face is without eyes, nose, mouth and ears. But it does bear one remarkable feature, a black ring placed at about mouth level, and held by black ribbons. Willard Bohn has pointed out the source of this characteristic emblem, which, he says, was intended both to represent a mouth and to mask the mouth that is not there. Neither Apollinaire's 'Musicien de Saint-Merry' nor Savinio's Bald Man had a mouth or a voice, but they were able to play the flute and sing. So, when put on stage, these two figures, despite their masks, had to be in a position to perform these activities. Savinio visualized this in his figurines for the performance of *Les Chants de la mi-mort*, and Apollinaire followed his lead in his planned 'Musicien' pantomime, by giving the faceless head a ring as an artificial mouth aperture. According to Baldacci, this ring recalled the 'punched disc of rubber or metal' inserted into a horse's throat after a trachea operation 'to enable it to breathe.'

But de Chirico was apparently not happy with the position of the ring. He soon shifted it to the point on the featureless face where the forehead should be. And he inserted a small star into the circle – thus giving his figure the eye of a Cyclops, and transforming him into a visionary, a seer. *The Seer* who gazes out at us from the eponymous painting of 1915 is philosopher, poet and artist in one, the painter's *alter ego,* and at the same time represents his father.

# Giorgio de Chirico
## *The Disquieting Muses*, 1918

A stage, its boards depicted in fleeting perspective, stands in front of Castello Estense in Ferrara, seen in the background. Next to it rises a medieval watchtower – not present in the actual northern Italian town – and, as the greatest possible contrast, a modern factory building with two chimneys.

Three figures appear on the stage. In this case, de Chirico's trademark *manichini* take on an especially strong static and statuesque quality. It is probably justified to view the ancient statue on the right, standing in the shadow of a building with shuttered windows and dark arcades, as representing Apollo Musagetes, the leader of the Muses. The other two, crosses between column shafts and tailor's dummies, likely represent the Muses.

The figure on the left stands upright, while that in the middle is seated on a chest. This figure's head resembles a stump or pin, from which it has removed its actual head like a mask or helmet and set it down by its feet. This may have been intended as a general allusion to the significance of the mask as persona, for in early drama it was the mask that lent the actor his individuality, allotted him his role. So the present mask, depending on whether we see its features as primarily comic or tragic, can be associated either with Thalia or Melpomene. The identification of the other Muse must remain ambivalent as well. If we interpret the stave beside it as a closed writing scroll, the figure would be Calliope, the Muse of Poetry. But if it is simply a stave, it would refer, again, to Thalia, the Muse of Comedy.

This picture, as de Chirico wrote from Ferrara to Carlo Carrà in Milan, was originally to have been called *The Disquieting Virgins*, in reference to the Vestal Virgins of Greek myth. He had good reason to change the title shortly afterwards, since interpreting the figures as Muses seemed more suitable and more tantalizingly complex.

De Chirico's Muses have a profoundly melancholy air. Their attributes seem strangely distorted. Could such tailor's dummies with rudimentary heads actually be more knowledgeable than mere mortals, as myth reports? Able to predict the future, like the Oracle of Delphi? Aren't these omniscient beings themselves in need of succor and protection, vulnerable, homeless creatures? In the

Renaissance the palace of the Este family, who ruled Ferrara until 1598, was considered the home of the Muses. Since then, judging by de Chirico´s image, they were evidently cast out, and, abandoned and homeless in the present day, have altered beyond recognizability.

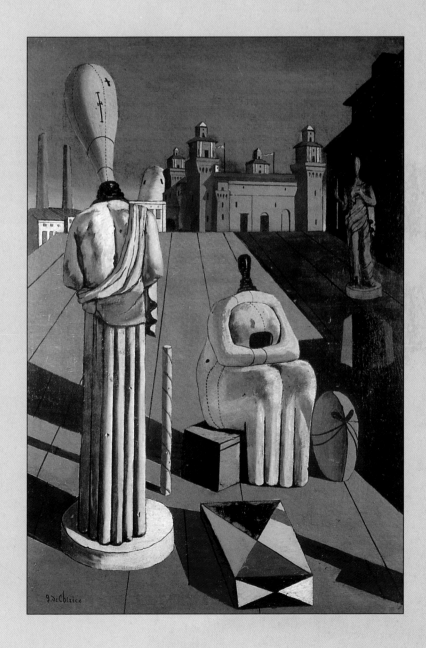

*The Disquieting Muses,* 1918
Oil on canvas,
97 x 66 cm
Private collection

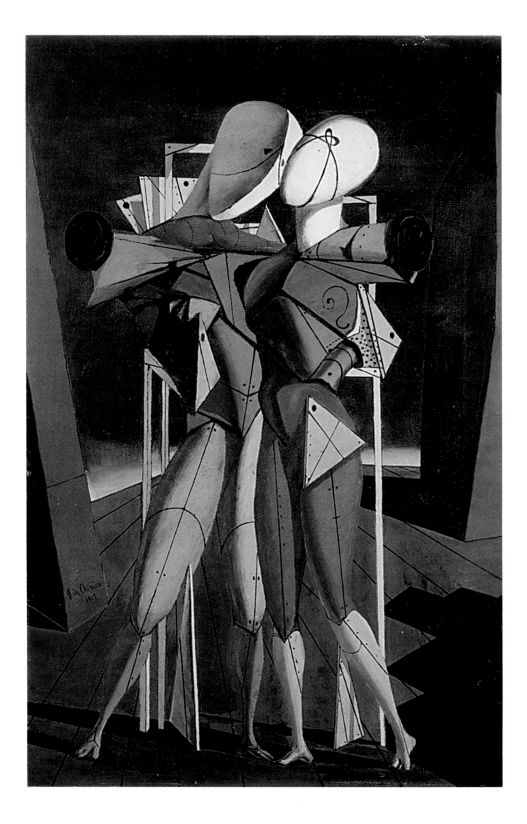

Opposite the *Seer* stands a school blackboard with a sketched image, probably from his own hand, a metaphysical picture with arcades, statue and mysterious symbols. It also contains the word TORINO, which was always a key word for de Chirico. This can be taken as a reference to the source of his inspiration, and to the fact that, despite the plethora of new topics discussed in the orbit of Apollinaire and *Les Soirées de Paris*, he never forgot the ideas and fate of Nietzsche. For it was the German philosopher who had taught him to interpret the figure of Ulysses, the statue of Dante, indeed the entire realm of phenomena, as signs and symbols. And so he set the philosopher on a plinth, called him a prophet, and made him into a monument. De Chirico's 'thinker on the stage' is none other than Friedrich Nietzsche.

# Act IV
# Max Ernst Breathes New Life into the Immobilized *Manichino*

Max Ernst's art was born of contradiction. He was an artist whose whole creative being was determined by fierce and fundamental opposition.

Now, this spirit of contrariness requires an object to chafe against if it is to bear fruit. Without such friction, no sparks will fly. Whatever this object may be, it must touch the artist and raise questions in his mind that concern him deeply and demand answers. It must be something that, far from leaving him cold, intrigues him and at the same time provokes resistance, that inspires and disturbs him, and that therefore demands to be adopted and reshaped in order to get to the bottom of its power to inspire and disturb.

Max Ernst first came across such visual material that challenged him to attack and intervene, in the work of Giorgio de Chirico and Carlo Carrà. He also found it wood engravings used to illustrate nineteenth-century popular novels, and in the elaborate lithographs in a teaching aids catalogue of an educational publisher in Cologne. There is a parallel here: Ernst encountered de Chirico's and Carrà's paintings and drawings not in the original, but in the form of black and white reproductions in the Roman magazine *Valori Plastici*, discovered at Goltz's, a Munich bookshop, in September 1919. It was a special supplement of the journal illustrated with twelve of De Chirico's paintings.

Ernst was familiar with the name of Carlo Carrà from pre-war Futurist exhibitions, such as that held in 1912 in Cologne. This may explain why Carrà's shift to metaphysical painting apparently struck him with less force than his encounter with de Chirico's imagery. This opened his eyes to an unknown world. Discovering de Chirico came as a shock to Ernst (as it did to many other future Surrealists). What he saw there must have struck him as the opposite pole to Dada's noise and commotion, and it is not surprising that the creative voltage immediately began to build between these poles.

Ernst and de Chirico seldom met personally, and a photographic record exists of only one meeting. It must have taken place in Paris, in November or December 1924. The photograph,

from the album of Simone Breton, André Breton's wife at the time, shows Ernst seated behind de Chirico on a carousel horse at a Montmartre fair. Visible in the middle is Gala Eluard, with whom Ernst had just returned from Indochina, and at the far right, the Surrealist poet Benjamin Perret.

However little they meant to each other personally, Ernst owed a great deal to de Chirico's art. It was no coincidence that he included the Metaphysician in his picture *Au rendez-vous des amis* (Rendezvous of Friends), done in Paris in 1922. He is part of the illustrious circle of the absent/present ancestors of the future Surrealists, including Raphael and Dostoevsky (on whose knee Ernst is perched). De Chirico is depicted in the style of his own *Disquieting Muses* (which Max Ernst had seen in reproduction in Munich in 1919), as if he had already turned into a monument to himself. Like a stone stylite, he gazes solemnly over the shoulder of André Breton, who rushes into the centre of the picture, his crimson cape wafting behind him.

Ernst has spirited his group of friends into the glacial realm of Nietzsche, that "voluntary life amidst ice and mountain peaks" of which the philosopher speaks in *Ecce Homo*. Elsewhere Nietzsche declared, "I want no insight without danger," and remarked, in the spirit of Zarathustra, "May the treacherous sea or the pitiless peaks

Max Ernst:
*Au Rendez-vous des amis* (Rendezvous of Friends, 1922)
Oil on canvas, 130 x 193 cm
Ludwig Museum, Cologne
(The second figure from the right in the back row – a statue – represents de Chirico)

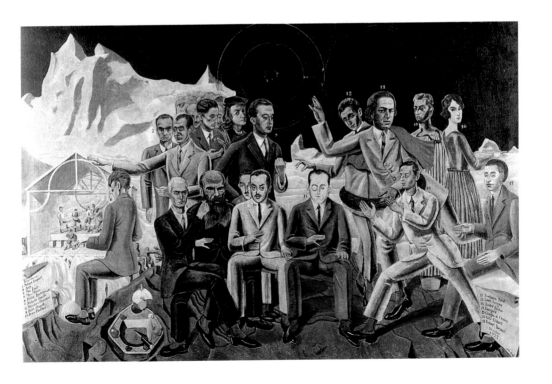

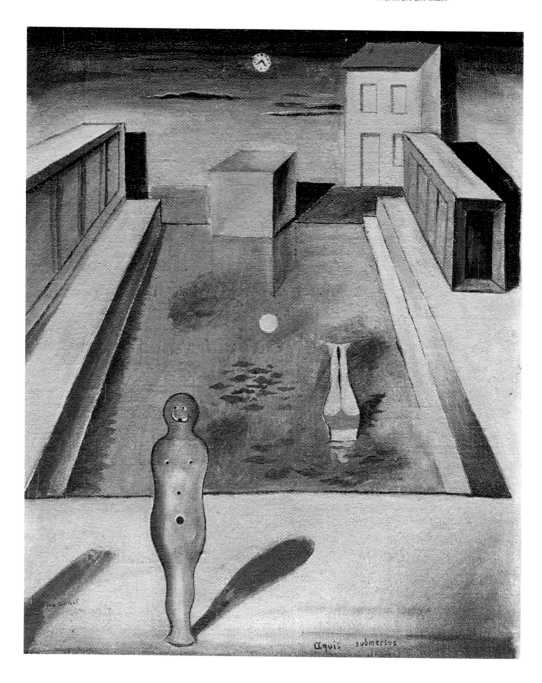

Max Ernst:
*Der Architekt* (The Architect), 1919
Relief, wooden objects found;
whereabouts unknown

always surround the seeker." Nor did the future Surrealists desire any insight – or any brand of art – that did not involve danger. Thus the forbidding mountain realm, especially during an eclipse of the sun, was definitely the right place for Ernst to put them. Its pure, clear air would encourage the unfolding of their imagination. In any case, the icy Alps and abysses in which Ernst placed his group of friends, aptly evokes the Surrealists' point of departure. It is a zone of cold and numbness, still at the low temperature of metaphysical imagery and suffused by its light that does not warm. Thawing this numbness would soon become one of the Surrealists' most important goals.

Ernst's initial response to de Chirico's imagery gives us a glimpse of the deep-seated attitude of opposition which would bear such rich fruit in his work. In his painting *Aquis submersus*, done in autumn 1919, immediately after seeing the de Chirico reproductions in *Valori Plastici*, he ironically populated a typical Italian piazza in the spirit of Dada. (The elements were derived from various sources; Ernst had probably not yet seen de Chirico's 1912 painting *The Delights of the Poet*.) De Chirico's rectangular pool with fountain has become a swimming pool, into which one of de Chirico's melancholy, meditating figures is diving head-first. The arcades on the left have been transformed into changing cubicles, and the hands of de Chirico's station clock now adorn the moon. The Italian artist's quiet urban square has been flooded and awakened to ghostly nocturnal life.

Water is a vital element, and signifies growth; all life began in the primal waters. It is no coincidence that water evaporated from de Chirico's pictures at an early stage. It figured prominently for the last time in *The Delights of the Poet*. From then on, the sea was rarely visible, remaining hidden behind a wall, above which a sail occasionally jutted. If a fish was included in the ensemble of objects, it appeared on dry land, or in the shape of a baking mould. A fountain would not appear again until 1917 – significantly, at a far distance, as a picture within the picture – followed in 1918 by a waterfall and a beach with lighthouse. So it was perhaps not entirely by chance that Ernst commenced his enlivening of de Chirico's world by flooding the arid ground of his Italian piazzas.

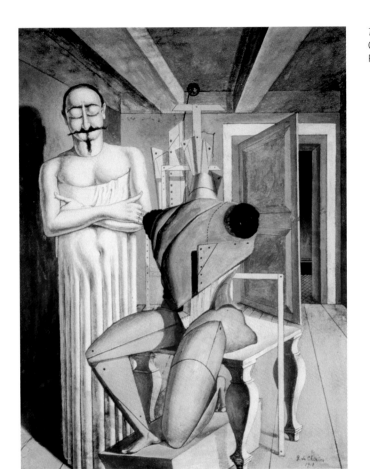

*The Apparition of the Ghost*, 1917/18
Oil on canvas, 94 x 78 cm
Private collection

It was probably de Chirico's *Great Metaphysician*, 1917–18, which had been published in *Valori Plastici,* that served as Ernst's point of departure for *Aquis submersus*. At any rate, he dealt with that painting in a series of other works of the period, for instance the assemblage of found objects called *Architect*. This headed a series of wood reliefs, most of them since missing and documented only in photographs, all dating from autumn 1919. Werner Spies managed to trace this group of works and has provided an exemplary interpretation (see *Max Ernst*, exh. cat., Centre Pompidou, Paris, 1998).

De Chirico's *Great Metaphysician* is a wooden framework made up of geometrical and draughting instruments, placed in an empty, Ferraresque square surrounded by Renaissance buildings. In *Architect*, Ernst brings the *Metaphysician* a step closer to life by translating the two-dimensional picture into a three-dimensional relief, rebuilding the figure with oblong blocks and a bobbin and giving

him a companion. Redeemed from his numbing loneliness, the self-doubting *Metaphysician* becomes an architect perhaps capable of building a new world – even if is only a dreamworld.

The *Architect* is an example of the transition from two-dimensional image to relief, collage to assemblage, of that thin line on which Ernst's art balanced at the time. The frame was included in the pictorial events, which simultaneously threatened to explode it. It was as if the third dimension – indeed life itself – had intruded itself upon the artist's work, and he had no choice but to react.

Ernst responded to de Chirico's solemnly staged mourning with irony, and replied to his imminent paralysis with a liberating laugh. De Chirico's pictorial world was galvanized by a jolt of Dada, a high-tension current that resulted in Ernst's *Fiat Modes, pereat Ars*. This portfolio of eight lithographs was executed in winter 1919–20, when Ernst returned to Cologne, and its printing financed with his unemployment benefits.

Max Ernst:
*Pietà oder Die Revolution bei Nacht*
(Pietà, or Revolution by Night), 1923
Oil on canvas, 116 x 89 cm
Tate Modern, London

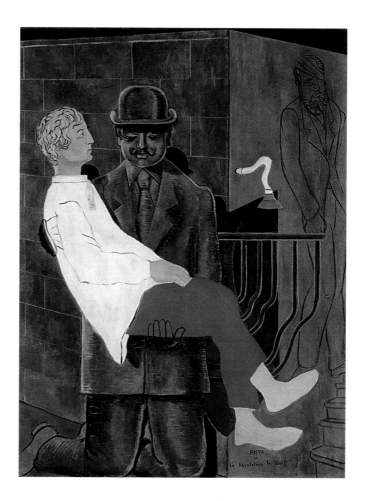

# Max Ernst
## *Celebes*, 1921

*Celebes* – also known as *The Elephant of Celebes* – was one of Max Ernst's first 'proto-Surrealist' paintings. In it, inspired by de Chirico's metaphysical imagery, he transcended the Dadaist impulsiveness that had shaped his early work and prepared the ground for Surrealism in painting. Done in 1921 in Cologne, *Celebes* intrigued Paul Eluard when he saw it in Ernst's studio on their first meeting. He immediately bought the picture and took it back to Paris to show his friends.

An enormous creature, faintly reminiscent of an elephant or the shape of the Indonesian island of Celebes, has stepped on to de Chirico's stage. The scene lends it stability, a sense of reflecting complex associations, a vague feeling of threat. The creature stems from the world of collage, which Ernst had explored since 1919. Cutting separate bits of imagery he had found out of their original context, the artist recombined them into new, surprising visual phenomena with entirely different meanings.

In the present case, Ernst's find was made in an English journal of anthropology. It was an illustration of a grain bin, made of clay and standing on two enormous feet, of a type once found in southern Sudan. In the painting, while retaining its contours, he transformed the bin into a metal monster with a hose-like trunk and a bull's head and horns, features taken from other existing imagery. Perched atop the creature, like a crown, saddle or antenna, is a Chiricoesque configuration of geometrical shapes.

The colossus is flanked by a pole, a pillar resembling a stack of hat blocks (a set piece from Ernst's collages), and a headless figure that alludes to de Chirico's tailor's dummies. The laws of perspective seem put out of joint by these objects and the strange shadows they cast. The flat ground extends uninterrupted to the horizon, where it is bounded by snow-capped mountains.

Ernst's response to de Chirico was based on contradiction. He instinctively resisted the fundamentally melancholy mood of the *Metaphysician*, and began to turn the impulses he received into their opposite. De Chirico's stage, hermetically sealed by Renaissance facades, chimneys and walls, excluded the natural realm. Ernst proceeded to demolish the walls around de Chirico's urban

squares, revealing the existence of far horizons. Into the vacuum of de Chirico's cityscapes Ernst introduced the voluminous presence of a colossus that forces every other figure to the margins. If de Chirico was partial to stone monuments or anthropomorphic scaffoldings composed of drawing instruments, Ernst confronted these with creatures of his own making: hybrids of plants, animals and machines, animated relics from the early days of technology.

Admittedly, lifelessness and numbness still pervades the landscape stage Ernst has set up under a soaring sky in *Celebes*. Yet we sense that the clay colossus and the headless shell of a mannequin would soon begin to act under their own power. The birth of Surrealism was at hand.

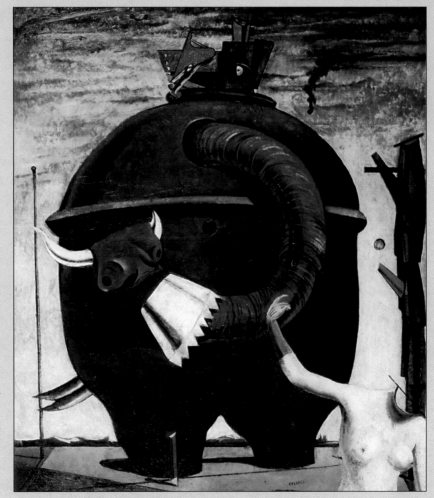

Max Ernst:
*Celebes (Der Elefant von Celebes)*
(The Elephant of Celebes), 1921
Oil on canvas,
125 x 108 cm
Tate Modern,
London

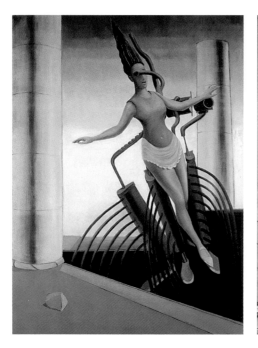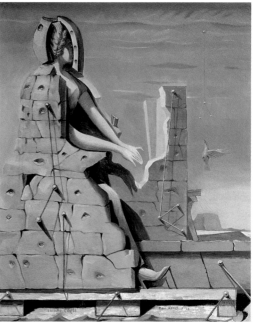

Ernst expressly declared the portfolio *Fiat Modes* an 'homage to de Chirico.' The German artist was particularly fascinated by two elements of his imagery, one relating to its configuration, the other to its content. Until about 1914, and then again from 1917–18 (the latter mostly published in *Valori Plastici*), de Chirico lent his compositions the form of a stage. On this stage performed – or rather, stood immobile – statues, tailor's dummies and plaster busts. It was as though they inhabited a space in which time had come to a standstill. Were it not for the occasional cloud suspended in the near-monochrome (usually dark green) sky, it could almost be called an airless space, a vacuum. Complete silence reigns. Nothing moves – except for a flag fluttering on a distant tower, even though there are no other signs of a storm. The façades of the houses around the claustrophobically sealed squares seem like stage-sets. There is no life behind them. Façades, statues and dolls cast long, dense, often illogical and mysterious shadows.

Max Ernst drew inspiration from both formal and iconographic aspects of these pictures. He took over the spatial stage with its eclectic perspective and exaggerated effect of depth, the sightless creatures and tailor's dummies, the principle of geometrical construction deprived of logical aim and rendered absurd, and finally, the alienating motif of the picture within a picture, which de Chirico and Carrà used to juxtapose incompatible realities. Yet even the

Max Ernst:
*Die schwankende Frau*
(Wavering Woman), 1923
Oil on canvas, 130.5 x 97.5 cm
Kunstsammlung Nordrhein-Westfalen,
Düsseldorf

Max Ernst:
*Die heilige Cäcilie (Das unsichtbare Klavier)* (St. Cecilia [The Invisible Piano]), 1923
Oil on canvas, 101 x 82 cm
Staatsgalerie Stuttgart

first works Ernst produced under the influence of de Chirico – the *Fiat Modes* prints – had a character all their own.

Ernst was fascinated, but not carried away. He approached de Chirico's eerie world in a spirit of irony. De Chirico's alienated tailor's dummy again became a real tailor's dummy, with a real, if faceless and robotic, tailor measuring it for a new suit of clothes: *Fiat Modes* …. De Chirico's *manichini* learn to move, initially, in *Fiat Modes*, like marionettes, and later, as in the 1923 *Wavering Woman*, like sleepwalkers balancing along the ridge of a roof. Ernst breathed dream-life into these figures, who seemed on the verge

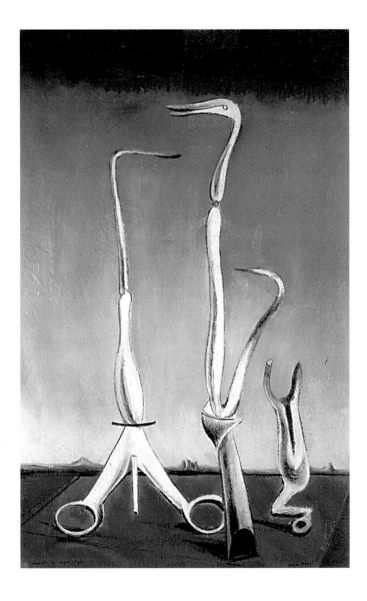

Max Ernst:
*Vögel in einer Landschaft (Landschaft mit Vögeln)* (Birds in a Landscape [Landscape with Birds]), 1922
Oil on canvas, 80 x 53 cm
Private collection

of waking at any moment. In both the painting and *Fiat Modes*, de Chirico's solid columns and towers begin to sway, fall and crash. Already in the first print of the lithograph sequence we see the tailor's journeyman taking the measure of a *manichino*, a tailor's dummy, as if preparing to make something of him.

Ernst understood the visual content of de Chirico's works like no one else. He was deeply affected by the immobility that confronted him in this Piazza d'Italia world. Everything seemed to have been transformed into architecture. Human beings had become statues, mannequins, wooden frameworks, shadows, and their heads had stiffened into masks. All signs of life seemed extinguished. These were pictures that could have been painted by a dead man – an artist who had succumbed to the sorrows of the world.

Then along came someone who rebelled, raised his voice in protest. Someone who said, We shall see whether this pain cannot be borne. Someone who objected to melancholy and resignation and drew courage from his own art. And who had a crucial weapon at his disposal – irony. Ernst's response was sparked by the radical vitality of Dada, which he cultivated above all with his friend, Baargeld, during their postwar years in Cologne. He recalled the prevailing attitude in his autobiographical notes: "Outrage over the status quo, the root of all evil. Enthusiasm for the emergent, the source of all joys. Therefore, action on two fronts: political and poetic, and in the only way that was possible at the time, a *desperate affirmation of life* in work and behaviour."

De Chirico's art declared, It's all over. The only thing we can do now is mourn the past. Those who walk my empty streets move through a doomed, buried world.

Ernst reacted to this message as he constantly reacted to the art of the past. He rebelled. He set out to break the spell of moribundity and death, to dispell the curse, cancel it with a counterspell, and thus make not only life but art possible again, give art a new lease on life.

The proto-Surrealist works of 1921–24, the 'painted collages,' show Ernst emancipating himself, step by step, from the spell de Chirico had cast over him. He took the engimatic, dreaming father figure from de Chirico's *The Child's Brain*, 1914, and adapted it to his own dream. In *Pietà, or Revolution by Night*, 1923, the dreaming father holds the statue- or doll-like figure of a young man. It is as if he were the young man's godfather, affectionately and protectively embracing him. Although the father figure is still lost in dreams, the young man's eyes are open. He is wide awake. This image has the effect of a visual manifesto. The Surrealists, it seems to

*The Corsair (The Pirate)*, 1916
Oil on canvas, 80 x 56.2 cm
The Albert C. Barnes Foundation,
Merion

say, dream with their eyes open, fully conscious, despite the fact that they still rely for support on their father figure, de Chirico. The title of the picture underscores this message. The revolution the Surrealists are plotting will be launched under cover of night, from the realm of dreams and the subconscious mind.

Many pictures by de Chirico, especially those of his Ferrara period of 1915–18, convey a feeling of claustrophobia. It was precisely these Ferrara pictures that Ernst came across first, in *Valori Plastici.* Some of his own works, like *St. Cecilia* or *Long Live Love – Pays Charmant,* both 1923, were dominated by the motif of captivity, of being shut in. St. Cecilia was trapped in a clay structure reminiscent of reinforced moulds for casting sculpture, and her sister, in *Long Live Love,* was encased in a shell as if made of tree bark, a kind of cocoon. This claustrophobic confinement was the legacy of de Chirico. In his work, the rigidity of a statue or tailor's dummy connoted invulnerability, a sad but ultimately accepted destiny. With Ernst, this state represented a provocation to break out, to rebel.

Ernst replied to de Chirico's resignation with Surrealist rebellion. At first he retained de Chirico's stage, but he emptied it. Away with the architecture, the arcades, the palazzi, the stations, the backdrops. De Chirico's city vanished as though wiped off the face of the earth by an earthquake or a volcanic eruption. The squares enclosed by confining walls and arcades made way for a bleak, open plain, with distant, snow-capped mountains on the horizon.

*The Two Sisters,* 1915
Oil on canvas, 55 x 46 cm
Kunstammlung Nordrhein-Westfalen, Düsseldorf

*Composition with Two Mannequins' Heads,* 1915
Oil on canvas, 70 x 54 cm
Private collection

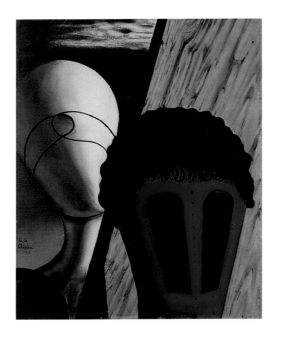

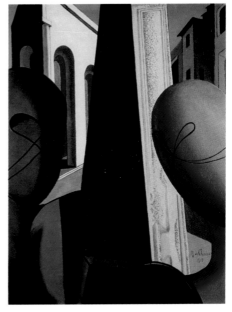

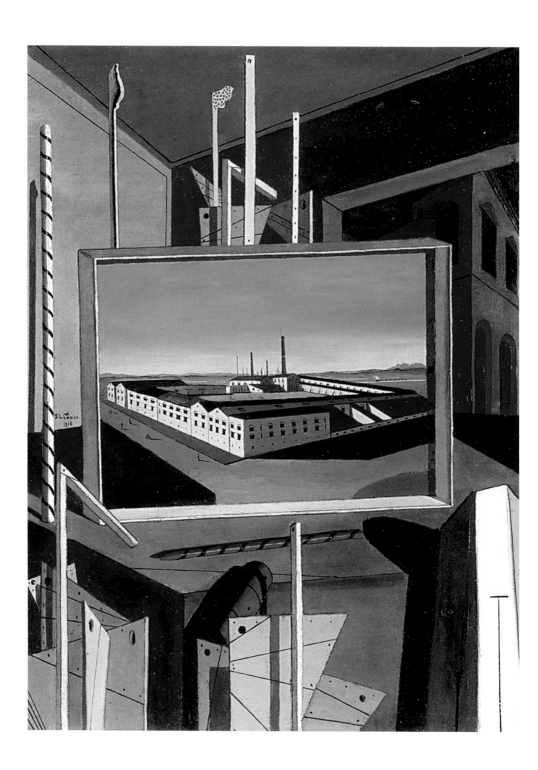

Yet at the same time, Ernst brought de Chirico's petrified world to life. He transformed its deathly numbness into blossoming dreams. He passed through de Chirico's squares, forsaken by god and man, like a fairy-tale prince, kissing the sleeping Ariadne and the unconscious Andromache to life, breaking statues and columns and liberating the figures trapped within them.

From 1921 onwards, the stage prepared by de Chirico was increasingly populated by Ernst's own creatures, transformed *trouvailles* from his Dada collages. One of the first was *Elefant von Celebes* (The Elephant of Celebes). This creature, derived from an African grain bin, stands on two thick feet of clay. It is fitted with a hose-like trunk and a hollow bull's head, and bears a Chiricoesque jumble of geometrical shapes on its back. Under the direction of Ernst, de Chirico's stage filled with hybrids of plants, animals and machines, animated relics from the early Industrial Age. The abandoned spaces of his metaphysical landscapes were colonized by creatures of Ernst's imagination and idiosyncratic iconography – tubes and hoses sprouted from the ground, monsters stirred in the housings of outmoded apparatus, metallic forests broke their slumber.

When Ernst changed a hose into an elephant's trunk or surgeons' tools and medical forceps into birds (*Vögel in einer Landschaft,* Birds in a Landscape, 1922), this indicated the direction which all of his reinterpretations would take. The path invariably led from the inorganic and technical to the organic and vital, never vice versa. Machines became living creatures, creatures that resisted metamorphosis back into machines.

Everything underwent metamorphosis, everything awakened, even if it was only to a dark, somnambulistic existence. *St Cecilia* broke out of her clay mould, the lovers in *Pays charmant* emerged from their cocoon. De Chirico's buildings and towers sprouted eyes and arms, hands and hair, and began dancing like spinning tops (*Ubu Imperator*, 1923).

Although the movements of these reanimated figures may still have seemed dreamy or mechanical *(Wavering Woman)* or associated with injury *(Oedipus Rex),* the deathly immobility of *Pittura metafisica* had vanished. In a few years, the *Zeitalter der Wälder* (Age of the Forests), Ernst's fish-bone trees, bird monuments, angels of the house, and brides of the wind would evoke a fresh, expansive space in which the stage whose boards once meant the world was forgotten. De Chirico's tragic vision of a lost Renaissance was supplanted by the proliferating growths of an enigmatic natural history. His ponderous statues began to levitate, hovering in the sky as *Monuments to the Birds*.

At this juncture it is important to note that the collage principle played a key role in de Chirico's work as well. It was one of his main creative resources for years, comparable in significance only to that of the spatial stage, which he developed to perfection. Given that de Chirico's compositions of 1910–14 and 1917–20 were largely based on this device of the stage, it is justifiable to describe the majority of those of the interim period, 1914–17, as 'painted collages,' in the same sense as this term is applied to Max Ernst.

The series of de Chirico's painted collages started with works like *The Fateful Temple* and *The Endless Journey*, both 1914, and culminated in the series of so-called 'metaphysical interiors,' painted in Ferrara. Here we shall look closely only at *Biblical Still Life* and *Wise Man's Revolt*, both dating from 1916.

All of these pictures share a number of design features in common that distinguish them from the earlier, and later, works composed in the form of a stage. One is the abandonment of spatial coherence in favour of an accumulation and interpenetration of many, contradictorily oriented planes. Another device is the abrupt illogical juxtaposition of highly heterogeneous objects from diverse levels and areas of reality: mythology and the contemporary world, Renaissance and Industrial Age, the noble realm of high culture and the trivial sphere of functional, everyday things. Objects from the real world confront objects from a second-hand, reproduced reality.

Yet however confusing the spatial context of de Chirico's collage pictures may be, however heterogeneous the origins of their juxtaposed objects – they are all viewed through the same nostalgic haze, as if they belonged to some inaccessible, lost world. Factory chimneys and locomotives, surgeon's rubber glove and metal placard in the shape of a glove, shop sign and commodities displayed in the shop window – de Chirico gazes upon all of these things with awe and astonishment, as though he were gazing upon the shrines of the ancient world.

De Chirico was fully aware of the collage character of his work, and occasionally he played with it to produce *trompe l'oeil* effects, as in *Greetings from a Distant Friend*, *The Corsair (The Pirate)* and *The Jewish Angel*, all executed in Ferrara in 1916. These compositions include an eye, outsized by comparison to the other objects, painted as if on a piece of cardboard and inserted later. One corner of the cardboard is bent up, and the shadow it casts on the card is painstakingly depicted – *trompe l'oeil* and a playful poke at its cheap effects at the same time.

Another aspect of *The Jewish Angel* is worth remarking. The structure, made up of geometrical implements and studio equip-

*The Jewish Angel*, 1916
Oil on canvas, 67.3 x 43.8 cm
The Metropolitan Museum of Modern Art, New York, loaned by the Gelman Collection

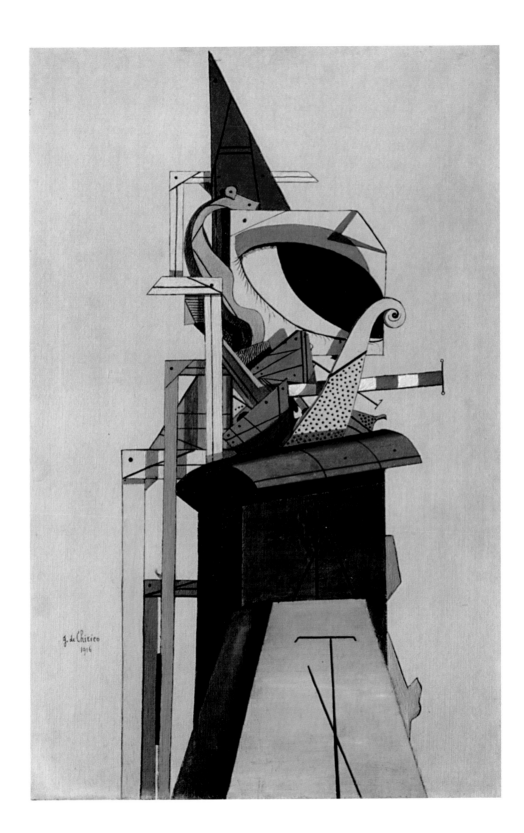

Max Ernst:
*Anthropomorphische Figur*
(Anthropomorphic Figure), 1930
Oil on canvas, 70.6 x 54.7 cm
Société Anonyme, Yale University
Art Gallery, New Haven

ment, triangles, rulers, measuring sticks, picture frames, and sections of angles and curves, is reminiscent both of an easel and a human figure. A gigantic eye – itself a geometrically precise construction on a piece of drawing-paper – sits at the top as if in lieu of a head. Would it be going too far to see this construction as a self-portrait? The self-image of a painter whose tools were an integral part of himself, just as were the fragments of ancient sculptures in *Metaphysical Self-Portrait,* 1913, and *The Great Metaphysician,* 1917–18, which likewise have the character of covert self-portraits. If Max Ernst had seen *The Jewish Angel* (which was not published until 1929), it may have inspired his own combination of self-portrait and artist's easel into the artificial figure he named 'Loplop.'

If de Chirico projected himself into his attributes and became one with his tools in *Jewish Angel,* Ernst went a step farther. In his *Portrait* or *Anthropomorphic Figure,* 1930, the easel-figure, with de Chirico still a monument paralysed into passivity, becomes active, advances towards the viewer. The motif of the picture within a picture, as found in de Chirico's *Metaphysical Interior with Large Factory*, takes on a quite different accent in Ernst's work. The portrait, evidently painted by the easel-figure himself, begins to detach itself and take on a life of its own. The artist's works leave his studio and he has no power over them any more.

# Act V
## *The Return of Ulysses*:
## de Chirico after de Chirico

And then something remarkable happened. Just as Max Ernst be-
gan reacting to the deathly immobility of de Chirico's world, the
figures on de Chirico's own stage came back to life. In the same
summer – 1919 – that Ernst came across the de Chirico reproduc-
tions in *Valori Plastici* and responded to them with his proto-Surre-
alist paintings, de Chirico's art underwent a strange transforma-
tion. Without at first entirely renouncing the 'metaphysical'
dimension of his imagery, de Chirico began increasingly to orient
himself to the art of the Old Masters, above all Raphael and Titian.
His memoirs, published in 1945, contain a lengthy description of
the awakening he experienced in July 1919, in the Galleria Borgh-
ese in Rome, in face of Titian's *Amor sacro e amor profano,* 1515.
He now grasped the essence of great painting, de Chirico wrote,
and that same autumn he published his now-famous essay, 'The
Return to Craftsmanship,' in Mario Broglio's *Valori Plastici*. This con-
tained the declaration that would shape his art from that point
onwards: 'Pictor classicus sum' (I am a classical painter).

So as Ernst explored uncharted art-historical territory, prepared
to meet adventures and make discoveries at every turn, de Chirico
returned to the Old Masters and the classical tradition, including
that of the painter's craft, which left very little room for experi-
ment. As Ernst breathed life into *trouvailles* from the realms of in-
animate matter, machinery and apparatus, de Chirico marshalled
figures that evoked a reanimated Graeco-Roman antiquity.

Even though they are depicted as living men, the two male
nudes who turn to look out over the open sea in *The Farewell to the
Departing Argonauts,* 1921, are entirely in tune with the sculptural
ideals of classical Greece, as de Chirico knew them from his youth
in Athens and from the Glyptothek in Munich. The two young fig-
ures in the left foreground are balanced on the right by a white-
bearded, bald figure, reclining with his elbow resting on the plinth
of a monument. Might he too have just climbed down from his
pedestal? Or was he originally sculpted in his present pose? That
same year, de Chirico depicted a reclining female figure as a stone
statue, as he once had depicted the mysterious Ariadne. Here,
the old man now appears as a creature of flesh and blood. Still,

he has not entirely awakened. Hardly come back to life, he has immediately fallen asleep again. Yet not before realizing his nakedness and modestly covering himself.

*The Farewell to the Departing Argonauts* shows us a world in a state of transition. The chilling climate of the metaphysical pictures has begun gradually to grow warmer. Yet no matter how great the overall change, the metaphysical memory lingered on, even in negation. De Chirico painted several versions of a *Paesaggio Romano* or *Rocce Romane*, a *Villa Romana*, a *Piazza Romana* that were a far cry from his *Piazza d'Italia*. Mercury, Orestes, Oedipus and Ulysses appeared, and no longer in the form of statues. Statues remained, but they were reduced to decorative accessories, standing in niches or on cornices, adorning a building façade or roof. Windows, previously mere rectangular apertures in a bleak façade, were set in an ornamental frame or cornice, had shutters and curtains, and behind the curtains, people appeared. Suddenly de Chirico's houses were inhabited. Warm air wafted into their airless rooms. Nature, previously excluded from a stone city-scape bounded by walls, now penetrated into the foreground.

*The Farewell to the Departing
Argonauts*, 1921
Tempera on canvas, 54 x 73 cm
Private collection

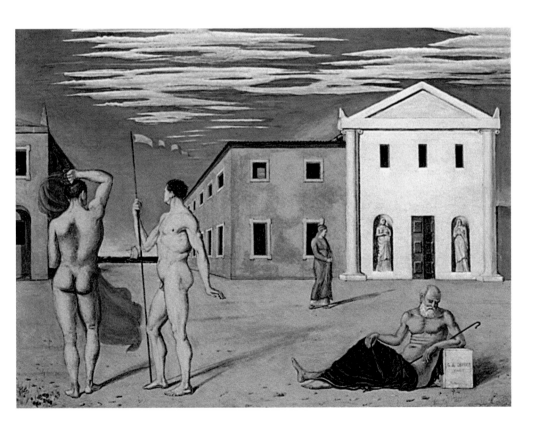

# Giorgio di Chirico
## *The Prodigal Son*, 1922

De Chirico painted *The Prodigal Son* at a time of transition. He had not yet detached himself completely from *Pittura metafisica*, but he had taken a new tack that would veer ever farther from the avant-garde routes and take him back to the art of the Old Masters. Although he had announced his 'return to craftsmanship' in the Roman journal *Valori plastici* in 1919, in 1920 he was still expressly stating, in a self-portrait, his commitment to a 'metaphysical' view of the artist's life.

*The Prodigal Son* exhibits many signs of this transition. The scene is set in a spacious urban square, but it is no longer the familiar Piazza d'Italia, entirely enclosed by walls and façades. The plank floors in paintings like *The Disquieting Muses* have disappeared; the figures now stand on solid ground, soil or clay. Although the square is still surrounded by a wall, it no longer separates the city from living nature. The landscape of Tuscany, familiar from the art of the Old Masters, comes on the scene, indicating the presence of human settlement. The chill of the earlier pictures has been banished; instead of an icy wind, a breath of warm air wafts into the scene, gently stirring the clouds in the deep blue sky.

De Chirico's staging of the return of the prodigal son is not without a theatrical touch. Two odd figures confront each other. Father and son have become complete strangers, and yet they are drawn together again. The father, a stone statue, has descended from his plinth (at the far right) to greet his son – a *manichino* that is patently artificial and still requires the support of a wood and wire stand. Still, the *manichino* does have an arm and a hand, which he lays tenderly on his father's shoulder to thank him for his warm reception.

De Chirico constantly returned to the theme of the prodigal son in the years 1919–25; it obviously concerned him deeply. The earliest drawing to bear this title and contain the motif of statue and tailor's dummy in an embrace, dates from 1917. There, traces of the statue's feet were still visible on the plinth. The dummy, armless, required the support of a more solid scaffolding made of drawing instruments to hold him up, and the scene was not set in a peaceful landscape. If back then, de Chirico associated the figure

of the prodigal son with his own return to his homeland of Italy, now it was linked with the idea of returning to the traditions of the painter's craft. The Old Masters have stepped down from their pedestal to welcome their belated son, who had been led astray by the avant-garde.

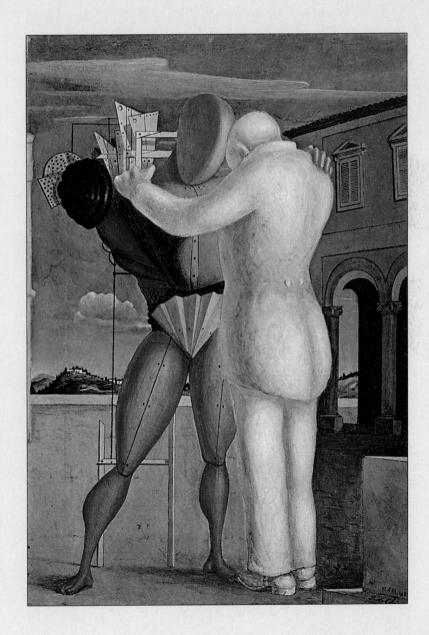

*The Prodigal Son*, 1922
Tempera on canvas,
87 x 59 cm
Civica Galleria d'Arte
Moderna, Milan

Trees grew next to buildings and clouds floated in the sky. The
human figures seemed to have woken from a long sleep, as if the
artist's enchanted mannequins had broken the spell and changed
back into flesh and blood, appearing on balconies, walking out
into the open air, and populating once abandoned squares. The
equestrian statues of the metaphysical period turned into real
riders, becoming knights of romance as early as 1923.

*The Prodigal Son,* 1922, perfectly captures the moment of tran-
sition from erstwhile paralysis to an age of new vitality – actually
a revival of the vitality of the ancient world. For this reason the
composition is discussed separately (see pp. 94/95).

Yet the development continued, and late Romantic artists like
Böcklin or Klinger followed the Cinquecento as important influ-
ences on de Chirico. In his metaphysical pictures he set up a stage
on which something he called a Mystery silently played itself out.
But in 1922–23, his compositions took on a theatrical aspect.
They were settings in which one could imagine a performance of
'Cyrano de Bergerac' or a drama like Max Klinger's 'Eine Liebe.'

The change that took place in de Chirico's art after 1919 can
be traced most precisely by looking at the self-portraits he painted

*Piazza Romana (Mercury and the
Metaphysicians),* 1922
Tempera on canvas, 56 x 76 cm
Private collection

in Rome and Florence from 1919 to 1924. At no other phase in his life did he portray himself more often. The surprising thing about these self-portraits is their changing facial expression. It oscillates between apparent self-doubt and triumphant self-confidence, between sadness and the assuredness of having found the right path at last.

In a *Self-Portrait* painted after his new insights, datable to 1920, de Chirico expresses these vacillating moods by depicting his personality in a double portrait. Here the artist confronts a stone or plaster bust of himself, which stands for two things: a testimony to the world of his past imagery, and a belief in his future fame. The painter gazes self-confidently out at the viewer, but seemingly without really being aware of him. Resting his chin on his right hand and his elbow on a window sill, de Chirico looks out of the picture. The metaphysical world of the old Italian squares is still present, but it has moved into the background. The painter has found his vantage point, his position with respect both to his life and his approach to art. The plaster bust of his metaphysical self, which seems to fix him with a sightless eye, scarcely disturbs him now. Though still close to him, it has been set aside. Is he still aware of this incarnation of his former vision at all? It is difficult to say. We only sense that de Chirico has attempted to depict himself as someone who is able to look his petrified past – both his early oeuvre and his tamed ego – coolly in the eye. And also as someone who has come to terms with a split existence, part vulnerable creature of flesh and blood and part a monument, devoid of all sensation. The painter of this self-portrait was aware of the double life that he would have to lead as an artist from that point on. He was prepared to accept it. And he was certain of the fame in store for him.

In a self-portrait dated 1924 – also known as *Self-Portrait in Stone* – the artist depicted himself as a half-length figure in high relief, both a statue and a living man, a further, complex reference to his inner conflict. The figure of the painter, resting his left arm on a balustrade, appears to be made of stone, as do the waves of the sea behind him. Yet the head, gazing at us with critical detachment, is flesh and blood. The background likewise undergoes a transition, from a frozen to an atmospheric state.

The pose in which de Chirico presents himself goes back to a Renaissance portrait type found, for instance, in the work of Raphael, Titian or Giorgione. De Chirico had written of Raphael's portraits in 1920: "The impression of otherworldliness and statuesqueness distinguishes Raphael's portraits from those of any other painter. It is concentrated in two works: the portraits of

Pope Leo X and Angiolo Doni, in the Galleria Pitti. On the rotund, mighty head of the pope, who looks like a Roman pro-consul, the flesh sits like granite."

And it was like granite that de Chirico depicted his own body. This breast will never feel pain again, never. This body has become invulnerable, has withdrawn from the stings and arrows of the contemporary world and been endowed with permanence. It has become a living monument – just as Ernst saw de Chirico in 1922, in his *Rendez-vous des Amis*. He was no longer of this world.

The series of self-portraits done in the early 1920s includes two in which, scholars largely agree, de Chirico portrayed himself in the role of Ulysses – despite the scant portrait likeness. Dating to 1922 and 1924, they once again referred back to Arnold Böcklin. But this time it was not the figure of Ulysses from the 1883 painting that inspired de Chirico, but the 1869 picture *Odysseus am Strande des Meeres* (Ulysses on the Seashore). Here Böcklin evoked Ulysses's yearning for home much more theatrically than in the later figure, standing with his back to us on a rock and lost in thought. This Ulysses seems to be suffering without hope of respite. He extends his arms towards the sea as if grasping for the void. Despairing of ever being able to continue his journey,

*Double Self-Portrait*, 1920
Oil on canvas, 39 x 51 cm
Toledo Museum of Art, Toledo

*Hermetic Melancholy*, 1918/19
Oil on canvas, 62 x 50 cm
Musée d'Art Moderne de la Ville Paris

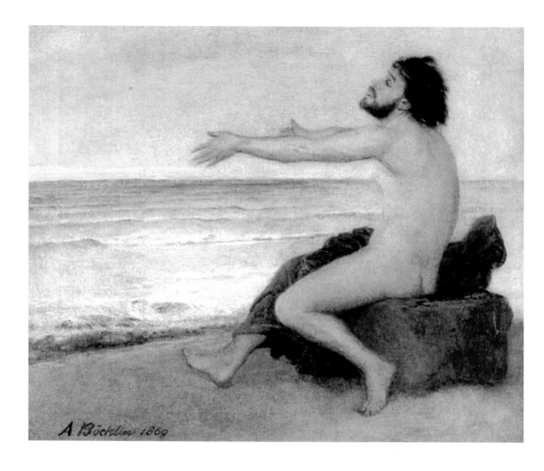

he imagines that he will be trapped on Calypso's island for the rest of his days.

To my way of thinking, the turn to this earlier, 1869 portrayal of Ulysses rather than to Böcklin's 1883 picture says a great deal about de Chirico's state of mind at the time. In the period between Böcklin's two Ulysses paintings – approximately corresponding to that between the different versions of *Villa by the Sea* and *The Island of the Dead* – the artist's approach had made considerable progress. Yet de Chirico, as if the development of his own painting from 1909–19 had never been, recurred to the portrayal that much more directly emphasizes Ulysses's suffering as an unwilling captive on the island of Ogygia. Basically, what we see here is an actor tearfully attempting to convey Ulysses's pain. This is a far cry from that sublimation of pain into silent melancholy that once moved de Chirico in Böcklin's *Ulysses and Calypso*. De Chirico's Ulysses turns with a dramatic, indeed pathetic, appeal to the viewer.

Arnold Böcklin:
*Odysseus am Strande des Meeres*
(Ulysses on the Seashore), 1869
Oil on canvas, 47 x 55 cm
Private collection

*Ulysses*, 1922
Tempera on canvas, 90 x 70 cm
Private collection

*Self-Portrait (in Stone)*, 1924
Oil on canvas, 74 x 62 cm
Private collection

*Ulysses*, 1924
Tempera on canvas, 92 x 71.5 cm
Private collection

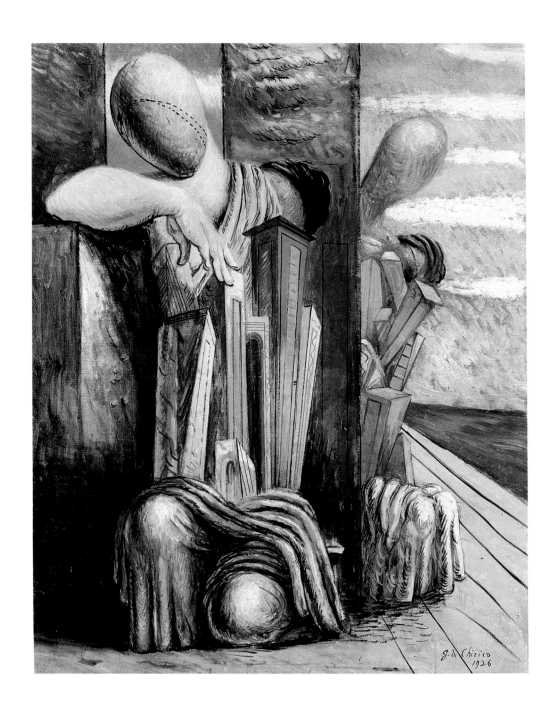

*Mannequins on the Seashore*
*(The Philosopher's Repose)*, 1925–26
Oil on canvas, 92 x 73 cm
Civico Museo d'Arte Contemporanea,
Milan

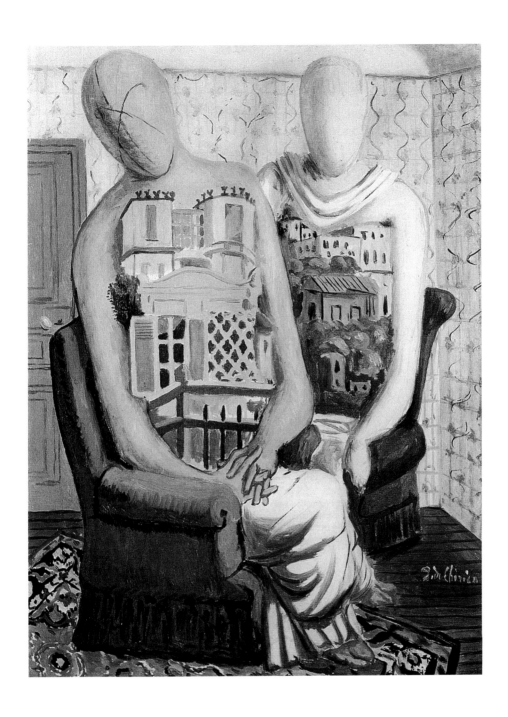

*The Muses (on Their Summer Holiday),*
1927
Oil on canvas, 73.2 x 54 cm
Private collection

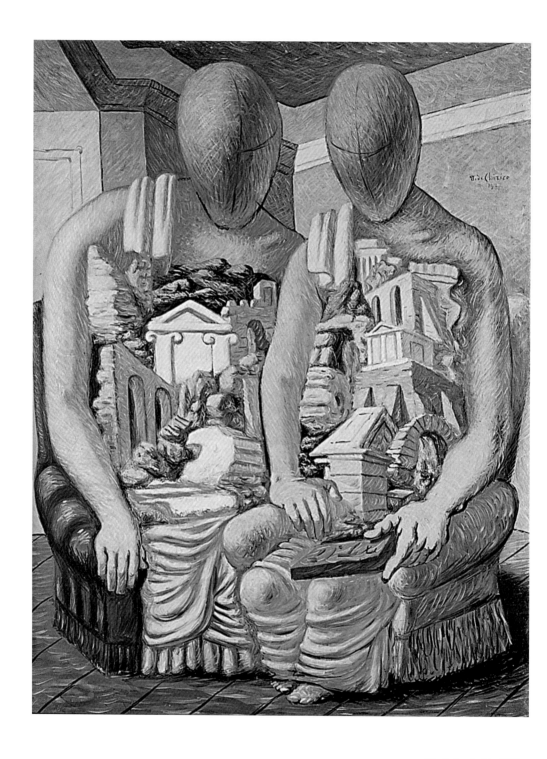

*The Archaeologists*, 1927
Oil on canvas, 118 x 91 cm
Private collection

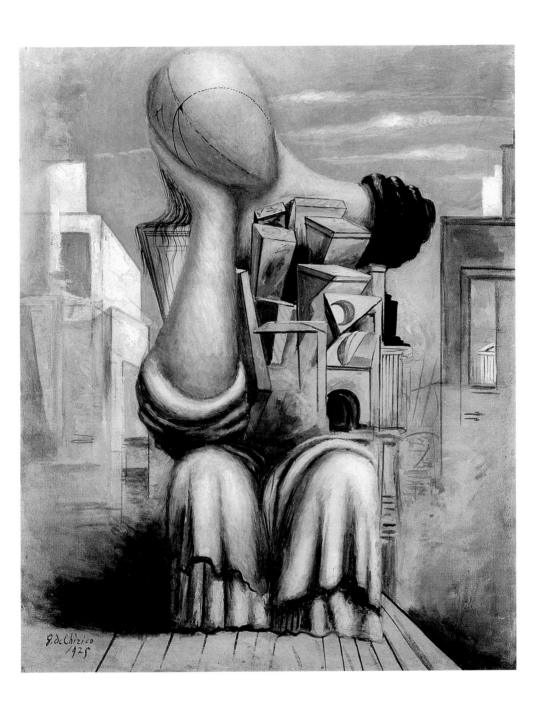

*The Terrible Games*, 1925
Oil on canvas, 81 x 65 cm
Private collection

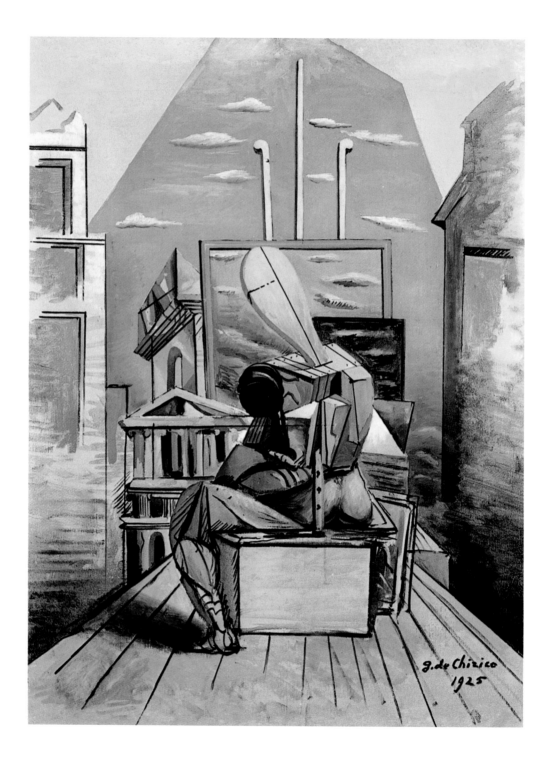

Apart from their formal treatment, his 1922 and 1924 pictures differ only in a single but important detail: the second is staged much more theatrically, with Ulysses acting a part in a play. The curtain is drawn aside. The hero seems to appeal for help, playing on the audience's sympathy and demanding its applause. But it is more than uncertain whether this Ulysses will ever continue his journey.

Yet the artist continued his. In 1924 he returned to Paris on a visit, and the following year he settled there. In February 1925 he devoted an enthusiastic essay to the city in *Rivista di Firenze*, titled 'Salve Lutetia and Dream of Paris'. In it we read: "An inexplicable law compels man to turn to the horizon, where the sun sets .... In Europe, Paris is the Western city par excellence. Not only people, but things ... ideas .. gravitate to Paris. These all surge over the earth and through the skies, across seas and rivers, and above all along those railway lines that know nothing of the surreal, to Paris. There things find their setting and their décor. Transformed, made more mysterious and brilliant against the great, grey sky of the city, which enables them to recover, they acquire a new lustre. The colours grow denser, lighter and richer ...."

And of course de Chirico could not help but think of his old travelling companions, Homer and Ulysses. "Even the mysterious Homer ... would revive again in Paris," he declares. "In the enchanting season when the shores of France are alive with bathers in colourful attire, his spirit roams the display windows of Galeries Lafayette." Homer must have been flabbergasted by what he saw there. The list becomes wearying: "Seashells, marine creatures, pebbles polished by centuries of work by the waves, and in the background, a hint of a sail .... We cannot help but think of Ulysses and his fateful wanderings."

For de Chirico, Paris in 1925 meant an attempt to make a new beginning. He wanted to draw on the inspiration he had found between 1911 and 1915, and at the same time to improve upon it, in view of the 'progress' he had made in the craft of painting. "Transformed, made more mysterious and brilliant" – this was to apply to his pictures as well. And so he returned to the figure of the *manichino* and lent it a hybrid or dual existence. Although the figures remain faceless, they have shaken off their earlier paralysis. When two of them meet, they seem to be deep in conversation. De Chirico presents them in the role of philosophers, painters, archaeologists, each completely immersed in their own concerns. Their bodies are built of books and scrolls, of architectural elements, arcades, bridge arches, temple ruins, columns, building blocks, children's toys. Sometimes they are stuffed so full of such things and fragments that they seem incapable of motion.

*The Painter*, 1925
Oil on canvas, 81 x 65 cm
Private collection

The thorax of the figure of *Homer,* 1925, consists of a whole library. When grapes, apples and pears pile up into a still life with fruit that swells the *manichino*'s body almost to bursting point, we are put in mind of Archimboldo. Indeed de Chirico's private mythology of the 1920s comes perilously close to Mannerism. His erstwhile metaphysics have become what Jean Cocteau termed a *Mystère laic,* a lay mystery.

Giorgio de Chirico travelled a long way, and all too often his journeys seemed to lead him deeper into a labyrinth. Ariadne provided no thread to help him. We find him moving first in one direction and then in another, apparently without map or plan. Many of the approaches he temporarily adopted seem confusing and contradictory. Space prevents us from tracing all the stages of his life's journey here. Let us look at only one further painting. It dates to 1968, and belongs to the 'neo-metaphysical period.' It is called *The Return of Ulysses.*

Once more, near the end of his road, de Chirico took up the figure of Ulysses, the man destined to wander and continually go astray, under whose sign the artist once set out on his own voyage.

*The Return of Ulysses,* 1968
Oil on canvas, 60 x 80 cm
Fondazione Giorgio e Isa de Chirico

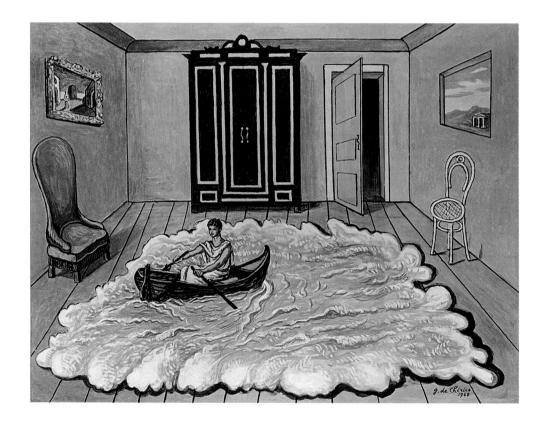

Ulysses is depicted rowing a small boat through restless waves. But these are not the waves of the sea; they are ripples on a pond that hos somehow found its way into a living room. Has he returned home from an ocean voyage, to relive in memory the dangers he has faced and mastered? Or were his adventures nothing but a dream, and he has never left the home of his yearnings? We do not know. De Chirico declines to answer.

The Ulysses he shows us here has become an ordinary, curly-headed youngster. He has nothing in common with the mysterious figure standing on Calypso's rock. He does not even measure up to the bearded actor of the 1920s. His odyssey, the picture seems to say, cannot have amounted to much. And so, as in Greek drama, tragedy is followed by burlesque. With this, 'de Chirico after de Chirico' takes leave of us. That he leaves us at a loss, one imagines, would have given him cause for one good, last chuckle.

# Epilogue:
# Prospects and Acknowledgements

I have concerned myself with Giorgio de Chirico's art for over forty years, and still find it as fascinating as ever. It continues to hold discoveries in store for anyone who is prepared to plumb its mysteries with an open mind.

In the late 1960s I was privileged to meet the painter personally in Rome, where he and his wife received me with great warmth. I accompanied him at many junctures during the final decade of his life – on a trip to New York, for example, and several visits to Paris. An ambition I had nourished for some time was fulfilled at an early stage of our acquaintance: the opportunity to help organise the first retrospective exhibition of his work, at Palazzo Reale in Milan, and then to take the show, for the Kestner-Gesellschaft, to the Orangerie of Herrenhausen Palace, in Hanover. De Chirico was over eighty at the time.

Certainly de Chirico could be difficult, and that not only in dealing with an admirer who was over forty years his junior. He concealed his true nature behind a façade of great politeness, even amiability. He was reluctant to make precise statements about his life and work, and enjoyed indulging in the occasional gnomic utterance. Some of the things he told me seemed stereotypical, as if rehearsed hundreds of times. I never saw him really 'let himself go.' It was as though he had already become a legend, indeed a myth, as though his due place was among the Olympians, and our hurry-scurry here below no longer concerned him. And yet there was much to be learned from being in his presence, as well as from what one saw and heard in the vicinity of his studio in Piazza di Spagna and among his circle of friends.

So it is perhaps understandable that research on de Chirico did not really get underway in earnest until after his death, when key documents became available. Many assumptions had to be revised, much that had been vague was clarified, and new and surprising facts came to light. Gradually a dependable stocktaking and precise chronology of the authentic early work, up to 1919, began to take shape, establishing the foundations for further art-historical investigation. These advances owed especially to the research and publications of three scholars, whose names hold first priority on

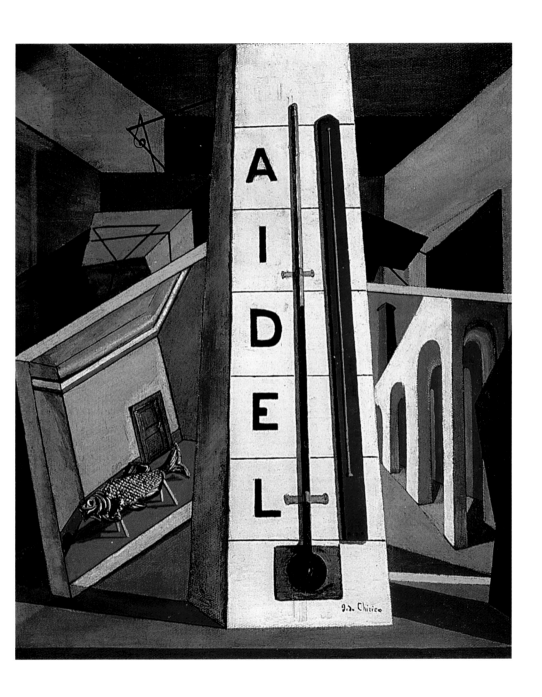

*The Dream of Tobias,* 1917
Oil on canvas, 58.5 x 48 cm
Private collection

my list of acknowledgements: Paolo Baldacci, Maurizio Fagiolo dell'Arco and Gerd Roos. I am indebted to their work for many points of detail, and every conversation with them provided an abundance of fruitful suggestions.

The work of Willard Bohn, Giuliano Briganti, Maurizio Calvesi, Giovanna dalla Chiesa, Giovanni Lista and Jole de Sanna – to mention only a few – has also been a source of great profit to me, comparable only to my early encounter with the essay by the great James Thrall Soby, whom I was once privileged to visit at his home in New Haven, Connecticut. The reader will find additional references to source literature in the bibliography.

Gerda Schwarz's essay on de Chirico's reception of classical antiquity, 'Cicero – Apollinaire. Zur Antikenrezeption bei Giorgio de Chirico,' published back in 1985–86 in volume 12/13 of *Grazer Beiträge – Zeitschrift für klassische Altertumswissenschaft,* did not come to my attention until shortly before the book went to press. The author advances what I feel are strong arguments to show

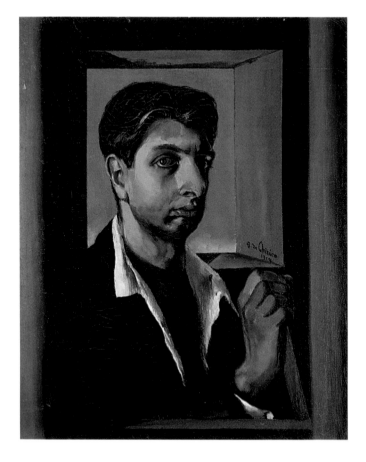

*Self-Portrait*, 1918
Oil on canvas, 62 x 50 cm
Private collection

that the classical bust with sunglasses in de Chirico's *Portrait of Apollinaire* was not intended to embody Orpheus – as Maurizio Fagiolo has suggested – but in fact represents a Roman portrait bust which, at least until recently, has been associated with Marcus Tullius Cicero. By the same token, Ms. Schwarz believes that de Chirico's obituary for the 'Roman centurion' Apollinaire represents a posthumous appreciation for having 'defended him here on earth.' Cicero was doubtless one of the most eloquent defenders in the ancient world. Still, identifying the bust with Cicero the rhetorician does not rule out the link with Orpheus, found in the fish and seashell. Rather, it merely adds a further dimension to the complex composition of the *Portrait of Apollinaire*.

I had the opportunity to contribute to some of the few international de Chirico exhibitions held in recent decades, and each time this brought new insights into a labyrinthine oeuvre that still has a great deal to yield. Of the other exhibitions I saw as a visitor, one in particular deserves emphasis. This was the event already mentioned in the introduction, 'A Journey into Uncertainty,' curated by Guido Magnaguagno and Juri Steiner for the Kunsthaus Zurich, and then shown in Munich and Berlin. It dealt in exemplary fashion with the links among Böcklin, de Chirico and Ernst, also discussed in the present book. Many key original works were on view, and every conceivable facet of the connections between these three major artists was addressed in the extensive catalogue. In the present book I have been able to cover only one aspect of the ties among Böcklin, de Chirico and Ernst – the transformations undergone by the human figure in their work. These are strange and fantastic enough, and will always play a central part in any discussion of the human image in modern art.

The text printed here as Acts II and IV goes back to two lectures that I have delivered on several occasions in recent years. They have been abridged and partially revised for the present book.                                                                 W.S.

# Giorgio de Chirico: A Chronology

**1888**
10 July: Giorgio de Chirico is born in Volos, the capital of Thessaly (Greece), into an Italian family that had lived in the Levant for generations. His father, Evaristo, an engineer from Istanbul, was in charge of constructing a railway line. His mother, Gemma, originated from Smyrna. Giorgio's elder sister died in childhood.

**1891**
Birth of Giorgio's brother Andrea Alberto, who would become a composer, author and painter and adopt the pseudonym Alberto Savinio.

**1900**
Giorgio attends the Polytechnic Institute in Athens, where he receives six years of thorough training in drawing and painting. His talent having become evident at an early age, before going to college he took drawing lessons in Volos, from a technical draughtsman by the name of Mavrudis, who was employed in Evaristo de Chirico's firm.

**1905**
Spring: Giorgio's father dies.

**1906–09**
Gemma de Chirico and her sons spend brief periods in Venice and Milan. 1906: They move to Munich. Giorgio attends the Akademie der Bildenden Künste for about two years, and Andrea has private tuition from Max Reger that autumn and winter, before moving to Milan with his mother in spring 1907. Giorgio is influenced by German literature and philosophy. He reads Schopenhauer and Nietzsche with particular enthusiasm, and studies the art of Arnold Böcklin and Max Klinger.

**1909**
Summer: De Chirico moves to Milan, where he lives with his mother and brother in their apartment in Via Petrarca. Autumn: Travels to Florence and Rome. Executes his first metaphysical pictures, such as *The Enigma of an Autumn Afternoon*.

*Portrait of the Artist's Brother*, 1909
Oil on canvas, 119 x 75 cm
Staatlicher Museen Preußischer
Kunstbesitz, Nationalgalerie, Berlin

**1910**
De Chirico moves to Florence with his mother and brother, staying there for over a year.

**1911**
January: Savinio gives a concert of his own compositions in Munich, and travels on to Paris. July: Giorgio and his mother follow his brother to Paris, to establish themselves there. On the way they spend a few days in Turin. The architecture of the city, like that of Munich and Florence before it, captures de Chirico's imagination. 14 July: Arrival in Paris.

**1912**
March: De Chirico volunteers for military service in Turin, but soon deserts and flees back to Paris. Three of his works are shown in the 'Salon d'Automne,' through the agency of Pierre Laprade.

**1913**
Early in the year, three works are included in the 'Salon des Indépendants,' followed by four works in the 'Salon d'Automne.' Apollinaire writes of de Chirico's 'metaphysical landscapes' in *Les Soirées de Paris*.

**1914**
Three works in the 'Salon des Indépendants.' Giorgio paints the *Portrait of Guillaume Apollinaire*. Ardengo Soffici writes about him in *Lacerba*.

**1915**
May: De Chirico takes advantage of the general amnesty offered on the outbreak of war to turn himself in to the Italian military authorities. He is given a physical examination in Florence and posted to the 27th Infantry Regiment in Ferrara. His duty in a military hospital (Villa del Seminario) permits him to devote himself to painting, and avoid eventually being sent to the front.

**1916–18**

The impression made by the architecture of Ferrara proves crucial to the development of his vision. He paints major works, such as *The Disquieting Muses, Hector and Andromache, The Troubadour, The Great Metaphysician,* and a series of metaphysical interiors. His poetic imagery lastingly influences Carlo Carrà, his companion at the military hospital from April to August 1917. Savinio, who served in the army in Ferrara before being posted to Macedonia, takes part in their discussions about art, as does Filippe de Pisis.

**1918–19**

Winter: De Chirico moves to Rome, where he initially lives with his mother in the Park Hotel. His paintings include the double portrait of himself and his mother. Visits the old art museums, especially Galleria Borghese, where he copies Lorenzo Lotto and succumbs

*Portrait of the Artist's Mother*, 1911
Oil on canvas, 85.5 x 62 cm
Galleria Nazionale d'Arte Moderna,
Rome, donated by Isabella Far
de Chirico, 1989

*Portrait of the Artist with his Mother*, 1919
Oil on canvas, 79 x 55 cm
Edward James Foundation, Worthing, England

to the fascination of Old Master painting in face of a Titian. Summer 1918: Roberto Melli introduces him to Mario Broglio, founder of *Valori Plastici,* an art journal for which de Chirico begins to write with great commitment. He visits the writers and artists associated with *La Ronda* magazine. May-June 1918: Participates in a group show on the premises of *L'Epoca.* February 1919: Mounts a one-man show in Anton Giulio Bragaglia's gallery in Via Condotti, featuring works from his metaphysical period in Ferrara. Roberto Longhi writes a devastating review in *Il Tempo. Valori Plastici* publishes a first monograph that includes twelve reproductions of his pictures, with commentaries by authors such as Apollinaire, Soffici, Blanche, Papini, Carrà and Raynal. André Breton reviews the book enthusiastically in *Littérature.* De Chirico would be featured in the 1921 'Young Italy' exhibition organized by *Valori Plastici,* which tours German cities, including Berlin and Hanover.

**1920–24**
De Chirico alternates between Rome and Florence, where he often lives and works in the residence of Giorgio Castelfranco. His painting increasingly reflects his romantic interpretation of classical art and his interest in early Renaissance technique. The Russian painter Nicole Lochoff introduces him to the fine points of *tempera grassa verniciata* (viscous oil tempera). 1922: Writes an important letter to Breton about 'questions of craftsmanship' and the 'secrets of his technique.' Executes *Roman Villas*, *Prodigal Son*, and *Argonauts* series. Develops metaphysical motifs from his earlier years in the new spirit and using new techniques. Important exhibitions: 1921: One-man show in Milan; 1922: 'Fiorentina Primaverile'; 1923: Biennale Romana (where Paul Eluard acquires works by de Chirico); 1924: XIV Venice Biennale. Autumn 1924: Revisits Paris for the first time.

**1925**
Autumn: Returns to Paris. Holds an exhibition in Léonce Rosenberg's Galerie de l'Effort Moderne. Catalogue preface by Giorgio Castelfranco. De Chirico's new paintings are attacked by the Surrealists. He publishes a monograph on Courbet in *Valori Plastici*. While still in Rome, met his future partner Raissa Gurievich-Kroll.

**1926**
Exhibits at Paul Guillaume's gallery in Paris (catalogue introduction by Albert C. Barnes, the famous Philadelphia collector who would acquire many de Chirico paintings) and at Galleria Pesaro in Milan. Participates in the first 'Novocento Italiano' exhibition.

**1927**
Further exhibitions in Paris, with Paul Guillaume and Jeanne Bucher. Roger Vitrac's monograph appears. Expansion of de Chirico's poetic repertoire by the themes of *Archaeologists*, *Horses on the Beach*, *Furniture in the Valley* and *Temples in the Room*.

*Self-Portrait with his Brother*, 1924
Oil on canvas, 87 x 67 cm
Private collection

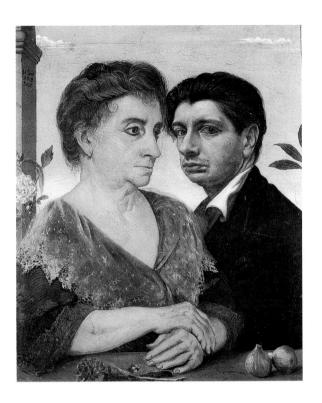

*Portrait of the Artist with his Mother*,
1921/22
Tempera on canvas, 64.6 x 54.7 cm
Private collection

1928
One-man show in London. Publication, in Milan, of Boris Ternovetz's monograph. Essays on his painting by Waldemar George, Pierre Courthion, Carl Einstein et al. Jean Cocteau publishes *Le Mystère Laic*, illustrated with etchings by de Chirico. In the meantime, the battle of words with the Surrealists continues, and Louis Aragon attacks him in a speech at an exhibition of collages at Galerie Surréaliste that includes some metaphysical images by de Chirico. André Breton publishes *Le Surréalisme et la peinture*, in which he praises de Chirico's pre-1918 paintings and condemns the later work. De Chirico publishes 'Piccolo trattato di tecnica pittorica' (A Short Treatise on Painting Technique).

1929
Designs sets and costumes for the ballet *Le Bal* by Rieti, performed by the Ballet Russe under the direction of its impresario, Serge Diaghilev. Publishes the novel *Hebdomeros* in French.

1930
Participates in several international exhibitions. Meets Isabella Far (Isabella Packswer) in the course of the year. Publication of Guillaume Apollinaire's *Calligrammes*, illustrated with de Chirico's lithographs. October: His first one-man show at Flechtheim in Berlin.

1931
Returns to Milan with Isabella Far and exhibits in the Galleria Milano, as well as in Prague (presented by Carrà), and other European cities.

1932
Lives and works in Florence. Exhibitions in the Palazzo Ferroni gallery, owned by the antiques dealer Luigi Bellini. Participates in the Venice Biennale.

**1933**
Exhibition in Genoa with Francesco Messina.
Paints a large mural in egg tempera for the Trien-
nale in Milan (later destroyed along with other
decorations in the exhibition). Designs sets and
costumes for Bellini's opera *I Puritani* for the
'Maggio Musicale fiorentino.' Returns to Paris at
the end of the year.

**1934**
Lithographs for Jean Cocteau's *Mythologie*, on
the subject of 'Mysterious Baths.'

**1935**
A separate gallery is devoted to his work at the
Rome Quadriennale.

**1936–39**
August: After a short stay in Tuscany, he travels
to New York, where he holds a one-man show
that autumn. Guest of the collector Barnes in
Merion, near Philadelphia, and decides to remain
in the United States with Isabella Far. Meets
Alexandre Iolas in New York. June 1937: De
Chirico's mother dies in Rome. January 1938: He
returns to Italy and settles in Milan, on Via Gesù.
Exhibitions in London and Paris. Autumn 1938: Moves to Paris
with Isa because of virulent anti-Semitism. 1939: Nevertheless
decides to participate in the 'Terza Quadriennale di Roma.' Late
1939: After the outbreak of war, returns to Milan.

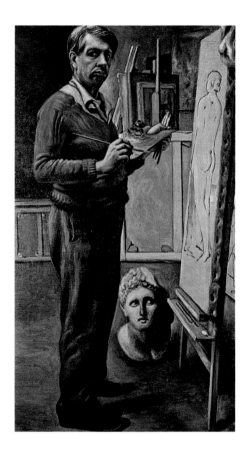

*Self-Portrait in his Paris Studio*, 1934
Oil on canvas, 130 x 78 cm
Private collection

**1940–44**
He illustrates the Apocalypse, which Raffaele Carrieri publishes.
James Thrall Soby's *The Early Chirico* appears. De Chirico Room at
the 1942 Venice Biennale. He spends the war years painting in
Florence and Rome.

**1945–47**
Settles permanently in Rome, first in Via Mario dei Fiori, then in Pi-
azza di Spagna, where he lives until his death. Publishes 'Memorie
della mia vita' and, in collaboration with Isabella Far, a collection
of essays, *Commedia dell'arte moderna*. Designs sets for Richard
Strauss's ballet *Don Giovanni*, performed at the Rome Opera under
the direction of Aurel Miloss.

1948
'Tre pittori italiani dal 1910 al 1920' exhibition arranged by
Francesco Arcangeli at the Venice Biennale. De Chirico denounces
the selection of works and takes legal action against the Biennale,
which has shown a forgery.

1949
One-man show at the 'Royal Society of British Artists' in London.
Continues to paint metaphysical and traditional works in parallel.
Italo Faldi publishes *Il primo de Chirico*, which is reviewed enthusi-
astically by C.L. Ragghianti.

1950–54
Various exhibitions in Rome and Venice. Publication of several
polemical essays. 1952: Death of his brother, Alberto Savinio.
1953: Isabella Far's first monograph on de Chirico appears.

1955
Exhibition of metaphysical works at the Museum of Modern Art,
New York. Publication of James Thrall Soby's standard work *Giorgio
de Chirico*. Takes part in the 'Quadriennale Nazionale d'Arte' in
Rome.

1961–67
Regular exhibitions at Galleria La Barcaccia in Rome. Exhibition at
Galleria Gissi, Turin, covering de Chirico's 1920–30 period. 1967:
Twelve works dating from 1914–28 shown at Galleria Galatea in
Turin.

1968
Exhibition at Galleria Iolas in Milan, with works on his new meta-
physical themes. Isabella Far publishes two further monographs on
de Chirico. He illustrates Salvatore Quasimodo's translation of ex-
cerpts from the *Iliad*.

1969
Luigi Carluccio's book *194 Drawings by de Chirico* published. The
drawings featured in the book shown in Turin, Geneva and Zurich.
Exhibition of the graphic works at Galleria La Medusa, Rome, to
accompany publication of the catalogue raisonné of the graphic
oeuvre, edited by Alfonso Ciranna.

1970
First retrospective at Palazzo Reale in Milan, and Kestner-
Gesellschaft, Hanover. Alexandre Iolas shows recent paintings,
sculptures and drawings in his galleries in Milan and Geneva, and
Claudio Bruni shows drawings and sculptures at Galleria La
Medusa in Rome. Autumn: Exhibition of pictures from the artist's
own collection under the title 'I de Chirico di de Chirico,' at Palazzo
dei Diamanti in Ferrara.

1971
Claudio Bruni begins publication of the catalogue raisonné in indi-
vidual volumes.

1972–73
De Chirico shows his collection of his own pictures in the Cultural
Centre on Columbus Circle, New York (then in Toronto) and travels

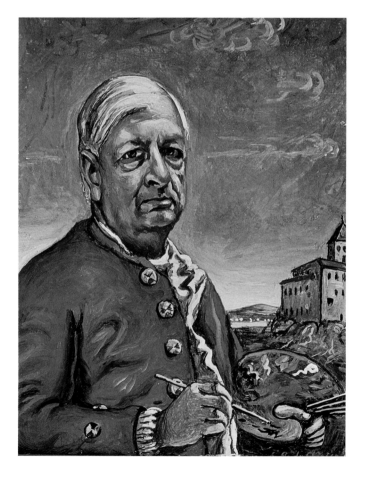

*Self-Portrait in Historical Costume*, 1956
Oil on canvas, private collection

to New York for the opening. The collection is subsequently shown in Japan.

1974
De Chirico is admitted to the Académie des Beaux Arts, Paris, as successor of the deceased Jacques Lipchitz.

1975
Exhibition at Musée Marmottan in Paris, arranged by the Institut de France. De Chirico is present at the opening.

1978
20 November: Giorgio de Chirico dies in a Roman hospital after a long illness, a few months after his ninetieth birthday. 22 November: Buried in the Cimetero Verano in Rome, in the Negroni-Floquet family vault.

1991
His mortal remains are moved to the Oratorio della cappella dell'immacolata della Chiesa Francesco d'Assisi a Ripa Grande in Trastevere, Rome, where he lies beside his second wife, Isabella Far (*d.* 1990).

# Bibliography

*The bibliography includes only literature that appeared after de Chirico's death in 1978.*

Bruni, Claudio [ed.], *Catalogo Generale Giorgio de Chirico*, vols. I-VIII, Milan 1971–87

Briganti, Giuliano/Ester Coen [eds.], *La Pittura Metafisica*, exhibition catalogue, Istituto di Cultura Palazzo Grassi, Venice 1979

Schmied, Wieland, Salon Jouffroy, Maurizio Fagiolo dell'Arco, Domenico Porzio, *De Chirico. Leben und Werk*, Munich 1980

Siniscalo, Carmine [ed.], *G. de Chirico. Poesie-Poèmes*, exhibition catalogue, Ferrara 1981

Coen, Ester [ed.], *La Metafisica. Museo docmentario*, exhibition catalogue, Ferrara 1981

Chirico, Giorgio de, *Poèmes Poesie,* ed. by Jean-Charles Vegliante, Paris 1981

Vivarelli, Pia [ed.], *Giorgio de Chirico 1888–1978*, exhibition catalogue, Galleria Nazionale d'Arte Moderna, Rome 1981

Fagiolo, Maurizio, *Le rêve de Tobie – un interno ferrarese, 1917 e le origini de Surrealismo* [Studi I], Rome 1980

Fagiolo, Maurizio, *Giorgio de Chirico. Il tempo di "Valori Plastici" 1918/1922* [Studi II], Rome 1980

Fagiolo, Maurizio, *Giorgio de Chirico. Il tempo di Apollinaire. Paris 1911–1915* [Studi III], Rome 1981

Calvesi, Maurizio, *La metafisica schiarita - Da de Chirico a Carrà, da Morandi a Savinio*, Milan 1982

Fagiolo dell'Arco, Maurizio and Paolo Baldacci, *Giorgio de Chirico. Parigi 1924–1929 - dalla nascita del Surrealismo al crollo di Wall Street*, Milan 1982

Rubin, William [ed.], *De Chirico*, exhibition catalogue, Museum of Modern Art, New York 1982

Rubin, William, Wieland Schmied and Jean Clair, *Giorgio de Chirico - der Metaphysiker*, exhibition catalogue, Haus der Kunst, Munich, 1982–83

Siniscalco, Carmine [ed.], *Poesie-poèmes e disegni di Giorgio de Chirico. II,* Nota al testo di Maurizio Fagiolo, Rome 1983

Fagiolo dell' Arco, Maurizio, *L'opera completa di De Chirico 1908–1924*, Milan 1984

Fagiolo, Maurizio [ed.], *Giorgio de Chirico. Il mecanismo del pensiero. Critica, polemoca, autobiografia. 1911–1943*, Turin 1985

*Giorgio de Chirico*, exhibition catalogue, Palazzo dei Diamanti, Ferrara 1985

Carlo, Massimo di, Massimo Simonetti, *De Chirico - gli anni venti*, exhibition catalogue, Palazzo Reale, Mazzotto 1987

Cavallo, Luigi [ed.], *Penso alla pittura, solo scopo della vita mia. 51 lettere e cartoline ad Ardengo Soffici*, Milan 1987

Fagiolo dell'Arco, Maurizio, Paolo Baldacci, *The Dioscuri. Girogio de Chirico and Alberto Savinio in Paris 1924–1931*, exhibition catalogue, Philippe Daverio Gallery, New York 1987/88

Fagiolo dell'Arco, Maurizio, *La Vita di Giorgio de Chirico,* Turin 1988

Dalla Chiesa, Giovanna, *De Chirico scultore*, Milan 1988

Calvesi, Maurizio [ed.], *De Chirico nel centenario della nascita*, exhibition catalogue, Museo Correr – Ala Napoleonica, Venice 1988/89

Braun, Emily [ed.], *Italian Art in the 29th century. Painting and Sculpture 1900–1988*, exhibition catalogue, Royal Academy of Arts, London 1989

Bucci, Moreno and Chiara Bartoletti [ed.], *Giorgio de Chirico e il teatro in Italia*, exhibition catalogue, Gabinetto Disegni e Stampe degli Uffici, Florence 1989

Schmied, Wieland, *De Chirico und sein Schatten. Metaphysische und surrealistische Tendenzen in der Kunst des 20. Jahrhunderts*, Munich 1989

Brandani, Edoardo, *Giorgio de Chirico. Catalogo dell'opera grafica 1969–1977*, Bologna 1990

Bohn, Willard, *Apollinaire and the faceless man. The creation and evolution of a modern motif*, London and Toronto 1991

Schmied, Wieland, *Giorgio de Chirico: Die beunruhigenden Musen. Eine Kunstmonographie*, Frankfurt am Main 1993

Lista, Giovanni, *Giorgio de Chirico. L'art métaphysique*, Paris 1994

Lista, Giovanni, *De Chirico*, Paris 1994

Schmied, Wieland, Gerd Roos, *Giorgio de Chirico. München 1906–1909*, Munich 1994

Baldacci, Paolo [ed.] *Giorgio de Chirico. Betraying the Muse. De Chirico and the Surrealists*, exhibiiton catalogue, Paolo Baldacci Gallery, New York 1994

Fagiolo dell'Arco, Maurizio, *De Chirico - Gli anni trenta*, Milan 1995

Braun, Emily [ed.], *De Chirico and America*, exhibition catalogue, Umberto Allemandi & C. The Bertha and Karl Leubsdorf Art Gallery at Hunter College of the City University of New York, 1996

Vastano, Antonio, *Giorgio de Chirico. Catalogo dell' opera grafica 1921–1969*, Bologna 1996

Baldacci, Paolo, *De Chirico. 1888–1919, La metafisica* (Catalogue raisonné), Milan 1997

Magnaguagno, Guido and Juri Steiner [ed.], *Arnold Böcklin – Giorgio de Chirico – Max Ernst. Eine Reise ins Ungewisse*, exhibition catalogue, Kunsthaus Zürich, 1998

Fagiolo dell'Arco, Maurizio [ed.], *Giorgio de Chirico. Metafisica dei Bagni misteriosi*. Exhibition catalogue, Vicenza et al. 1998

Fagiolo dell'Arco, Maurizio [ed.], *De Chirico - gli anni trenta*, exhibition catalogue, Galleria dello Scudo, Verona 1999

Roos, Gerd. *Giorgio de Chirico e Alberto Savinio. Ricordi e documenti. Monaco – Milana – Firenze 1906–1911*, Bologna 1999

Jole de Sanna [ed.], *De Chirico. La Metafisica del Mediterraneo*, Milan 2000

De Chirico, Giorgio, *Monsieur Dudron. Autobiographischer Roman*, from the French and Italian by Walo von Fellenberg, Bern 2000

Fagiolo dell'Arco, Maurizio [ed.], *Giorgio de Chirico. A Metaphysical Life*, exhibition catalogue, The Bunkamura Museum of Art, Tokyo 2001

*Front cover*: Giorgio de Chirico, *The Endless Journey*, 1914
(detail, see p. 47)
*Spine*: Giorgio de Chirico, *The Enigma of the Oracle*, 1909
(see p. 11)
*Frontispiece*: Giorgio de Chirico, *Self-Portrait*, 1920, oil on panel,
51 x 40 cm, Bayerische Staatsgemäldesammlungen, Staatsgalerie
Moderne Kunst, Munich
Page 4: *Giorgio de Chirico, Ariadne's Afternoon*, 1913, oil on canvas,
134.5 x 65 cm, private collection

Die Deutsche Bibliothek CIP-Einheitsaufnahme data and the
Library of Congress Cataloguing-in-Publication data is available

© Prestel Verlag, Munich · Berlin · London · New York 2002
© for the works illustrated by the artists, their hiers or  assigns;
with the exception of Giorgio de Chirico, Raoul Dufy, Max Ernst
and Pierre Roy: by VG Bild-Kunst, Bonn 2002

All pictorial material has been taken from the museum archive cited
or from the Publisher's, unless otherwise indicated

Prestel Verlag
Königinstrasse 9, 80539 Munich
Tel. +49 (89) 38 17 09-0
Fax +49 (89) 38 17 09-35

4 Bloomsbury Place, London WC1A 2QA
Tel. +44 (020) 7323-5004
Fax +44 (020) 7636-8004

175 Fifth Avenue, Suite 402
New York, NY 10010
Tel. +1 (212) 995-2720
Fax +1 (212) 995-2733

www.prestel.com

Prestel books are available worldwide. Please contact your nearest
bookseller or one of the Prestel offices listed above for details
concerning your local distributor.

Translated from the German by Michael Robinson, London
Edited by John W. Gabriel, Worpswede
Editorial direction: Christopher Wynne

Design and layout: Iris von Hoesslin, Munich
Lithography: reproteam siefert, Ulm
Printing and binding: Passavia Druckerei GmbH, Passau

Printed in Germany on acid-free paper

ISBN 3-7913-2794-1